An Introduction to Bird and Wildlife Photography

An Introduction
to Bird and
Wildlife Photography

In Still and Movie

John Marchington
and
Anthony Clay A.R.P.S.
with photographs by the authors

FABER AND FABER LIMITED
3 Queen Square, London

First published in 1974
by Faber and Faber Limited
3 Queen Square London WC1
Reprinted 1975
Printed in Great Britain by
Unwin Brothers Limited
The Gresham Press
Old Woking, Surrey

ISBN 0 571 10171 2

To our wives, who cheer us in defeat, encourage us in adversity, offer excessive congratulations for our occasional successes, worry silently when we are overdue from remote places, and generally tolerate, nourish and sustain us for, so it seems to us, little reward.

Contents

CONTENTS

Illustrations

The photographs including the jacket illustration are by John Marchington, with the exception of the following: plates 2, 3; P. Van Groenendael and W. Suetens: plates 4, 7; Peter Merrin: plates 5, 6; Anthony Clay

Foreword

by Robert Dougall, M.B.E.

President, the Royal Society for the Protection of Birds

One of the more hopeful signs of our time is that more and more people are beginning to realize that the quality of their lives does not depend solely on uncontrolled material progress. On all sides we find an ever increasing support for conservation movements and a mounting disapproval of pollution in all its forms. People of all types and all ages are taking a renewed interest in the countryside and undoubtedly one of the most challenging and rewarding hobbies to be followed there is wildlife photography.

I am delighted to have the opportunity of writing this brief foreword not just because I know this hobby gives pleasure, but also because any activity which takes us into the countryside with an understanding and observant eye can only be to our and the general good.

There can be few people better qualified to write a book of this nature than the joint authors who share a lifelong interest in natural history and photography.

John Marchington's photographs of wildlife appear regularly in a wide range of publications both in this country and abroad. He is a keen amateur and his honorary activities include serving on the Executive Committee of the Surrey Naturalists' Trust and the Management Committee of the Wildfowlers' Association of Great Britain and Ireland.

Anthony Clay is a professional and in his capacity as Films Officer of the Royal Society for the Protection of Birds has become well known to many thousands who have admired his work. The fact that, as a qualified banker, he gave up a city career to film wildlife speaks volumes for his enthusiasm.

I wish this book the success it so richly deserves.

Section One

GENERAL

by John Marchington

Introduction

This book is written for people who want to make a start in the fascinating hobby of photographing wildlife. There are several excellent publications at an advanced level but advice for the novice is hard to come by and Anthony Clay and I have tried to fill this gap.

Most people writing on a hobby or sport tend towards the fanatical and exaggerate its pleasures, and I suppose Anthony Clay and I, on the subject of wildlife photography, will be no exception. However, this is not my only interest and perhaps I can, therefore, make a more realistic appraisal than the man whose thoughts and energies are concentrated on one activity. For me one of the joys of the hobby is the wealth of people and places one meets in its pursuit. The player of, for example, golf, plays on different courses, but he will follow the same pattern. He will meet different people, but the majority will be similar types. This tendency to restrict the participants to a limited range of settings and people is common to many sports and hobbies, but the pursuit of wildlife with a camera involves contact with a great range of humanity. You meet the people of the countryside at all levels: farmers, keepers, landowners, stalkers, labourers, fishery officers, river keepers—a constantly changing pattern of faces and characters. The same great variety is found in the settings in which you seek your subjects, and the hobby will take you from the highest hilltops to the coastal marshes, from cornfields to heather moors, from small stream to vast loch, in fact to all the lovely and varied places of the British countryside. There are many side issues which bring interest and pleasure. One, of interest but doubtful pleasure, is the satisfaction of learning how to remain comfortable, or even survive, in severe weather. Another is the practice of man's inherited instinct to hunt, to plan and outwit the most wary and keen-sighted wild creatures. Having eventually solved

the technical problems of the equipment, and the physical problems of approaching the subject, you then give rein to the artist that lies within most people and try to obtain ever more attractive shots of each subject. You can never say 'I have a shot of a hare', rather like a particular New Guinea postage stamp, and cross hares off the list. The next step will be to photograph a hare running or in snow or crouching among wild flowers. Photographs which simply record a particular subject are useful and commendable, but the object must be to take artistically attractive photographs rather than technical records. With still life the ordinary photographer is concerned with composition and, where applicable, colour, but the wildlife photographer will often display his art by the posture of his subject.

Finally the hobby satisfies, for men at least, the love of mechanical things. There are a delightful profusion of bits and pieces to be screwed on and off, technical problems galore, and all manner of levers and knobs to operate. And if you are by nature a collector of gadgets you will have as much fun as any fisherman.

The first bird photograph was taken in the second half of the last century. Precisely which was the first is open to argument, but the following are certainly amongst the earliest:

1868 A. W. M. C. Kennedy—Birds in Bucks. and Berks.
1886 B. Wyles—Gulls in flight.
1887 J. C. M. Pleydell—Mute swan.
1870 C. A. Hewin—White stork at the nest in Grassborg.
1892 Cherry Kearton—Song thrush nest.
1895 R. B. Lodge—Lapwing.

The real credit for the development of the art must go to the Kearton brothers, Richard and Cherry, who were the first to use hides. They soon realized that their initial hides using animal skins were unnecessary and they developed the modern form of canvas square hide.

Since then the milestones have been:

1908 R. B. Lodge—First photograph of golden eagle and other birds of prey at bait.
1920 Tom Fowler and Ralph Chislett—Development of improved lenses and film.
1926 Oliver Pike and Edgar Chance—35 mm. cine film 'The Cuckoo's Secret'.

16

Late 1920s Frances Ward—First underwater shots of birds.

1930s Eric Hosking—First use of pylon hides.

1935 Eric Hosking—First bird photograph at night by flash bulb.

Early 1940s John Barlee—Birds in flight with 35 mm. 'small gauge' cameras.

1946 Eric Hosking—First bird photography by electronic flash.

Late 1940s—Introduction of improved quality colour film.

1960s—Rapid development of the 35 mm. camera and modern colour films and long focus lenses leading to 'snap shooting', work away from the nest.

If the history of the hobby interests you then track down:

Ralph Chislett—*Nature Photography and its Pioneers.*

Collins—*The Masterpieces of Bird Photography 1947.*

The Field—8 January 1938.

Gooders—*Birds of the World* (build up encyclopedia) Part 9 Vol. 9 page 2928.

By the limitations imposed by the equipment, heavy unwieldy cameras and slow films, the early days were essentially static, relying on photography on or around the nest from hides, or 'wait and see' photography which I will describe later. To obtain the best results these techniques are probably still the best, and much of the limited available literature is based on them. Certainly for the professional, who must always have money in his head, this is the road to results. I am not against it but it is, for all but the dedicated or the naturally slow, a dull business. One is pinned to a single spot, peering for hour after hour through a small hole, with a constant view, and dependent for interest upon whatever wildlife passes across this slender segment of vision. Given an active nest of youngsters there is much pleasure to be had, but if one is watching flies crawling over a dead rabbit bait, or three or four round balls of fluff in the nest, with a parent returning briefly at intervals of several hours, it is deadly dull.

The philosophy which pervades this book is that if one is a wild-life photographer for pleasure rather than profit, and this will apply to the majority of readers, then there is much more fun to be had going out and seeking the subjects than hiding away and waiting for them to come to you. In terms of results the actual photographs taken, when compared with hide work, will usually be inferior in technical quality, but will normally be freer, wilder and more

interesting. I would rather spend a day climbing to the 600 m. (2,000 ft.) level on a Scottish hill hunting for ptarmigan among the rocks, with a breeze in my face and a constantly changing panorama of scenery and clouds, than squatting in a hide.

This 'hunting with a camera' can take many forms and not all of them need be energetic. You can have the same pleasures pottering along the banks of a Dorset river after dragonflies and mayflies. The essential point is that one is roaming in the countryside experiencing new sights, sounds, smells and discoveries. Memories are every bit as pleasurable as prints stored in boxes. In my view this form of the hobby will increasingly take over from the hide for the amateur, not only because it is more fun but also because, at least as far as birds are concerned, it is becoming increasingly difficult to produce anything original. For example, even such a comparatively rare bird as the golden eagle has been well documented on and around the nest, but shots of it away from the nest are mainly of circling specks in the sky and there is enormous scope for 'free-range' photographs of this and most of the other birds. Badgers are another example: enough photos have been taken of badgers emerging from their sets and caught in the harsh light of a flash. If you are determined to take yet another then go ahead, but in my view your time and film would be better devoted to something new. The craze to photograph birds from hides has also led to a partial neglect of the many other things that run, creep, crawl, or even swim over our world.

My friend and co-author, Anthony Clay, who has written the section on cine photography, shares this philosophy, and has practised it on many occasions in the superb films he has produced for the R.S.P.B. Unfortunately for the cine enthusiast the need to hold the camera steady makes a tripod an important accessory, and the need both to carry and set up this equipment imposes limitations the still photographer rarely suffers.

In general then, this book is not aimed solely at telling you how to produce the best, or the greatest number, of wildlife photographs. It has the additional purpose of involving you in the countryside in the belief that this way gives greater pleasure.

When Anthony Clay and I first discussed the contents of this book it was immediately obvious that there would be no 'average reader'. Some would know much about the countryside and nothing about photography, some would be the reverse and in between would lie

the majority who would know something, in greater or lesser degrees, of each subject. Therefore, we have commenced each new aspect from an elementary beginning but progressed rapidly, referring the reader who seeks more detailed information to specialist books.

To save the 'still' photographer from having to wade through advice relevant only to cine work, and vice versa, this book has been divided into three sections. Section One deals with general matters of equal importance to both branches of the hobby. Section Two deals with still photography and Section Three with cine.

As you progress through the pages you may form the impression that Anthony Clay and I did not write it for the money. In this you would be right, although we would not like our good friends the publishers to carry this to the logical conclusion. We wrote this book principally to communicate our love of the countryside, the creatures in it, and the pleasure to be found in photographing them. We hope you derive as much pleasure from the hobby as we have.

1

The subjects and their lives

An important factor of success in wildlife photography, whether still or cine, is a basic knowledge of the pattern of life of wild creatures; the surroundings they individually choose to live in; and the factors which affect their movements and behaviour.

The British wildlife photographer is fortunate in living in a country which, within a relatively compact area, offers a wealth of habitat ranging from subarctic tundra conditions on the Scottish hilltops to the estuaries and salt marshes of the English coastline, from the cornfields of East Anglia to the water meadows of Sussex, and from the harsh coastlines but temperate weather of the Hebrides to the parks of London and other big cities. The activities of the farming community also vary enormously in influencing the country-side, sometimes tearing out most of the hedges and cultivating all but odd pockets, and elsewhere imposing just the very occasional boot mark of a passing shepherd. As a result the variation of conditions, whether as a result of man or nature, is enormous and many different types of creature find their own particular niches.

The great increase in population during the last century has imposed considerable strains upon our natural environment, destroying vast areas with a sprawl of concrete, tarmacadam and bricks. Fortunately the indications are that we perceive the danger, and the outcry against pollution has reached such proportions that it is reasonable to hope that the politicians will formulate the legislation necessary to strike a reasonable balance between the interests of man and nature. I use this somewhat temperate phrase because it is all too easy to hold forth emotionally against pollution and advocate measures which are downright impractical. More people must have more roads, factories, sewage farms, houses, schools, shops and all the other development that inevitably swallows land.

Wise government will divert these growths away from our best countryside but it cannot stop it. In a very small way the wildlife photographer plays a part in this battle for by producing attractive photographs of wildlife, he increases public awareness of the riches of the countryside.

Against this considerable threat of the growing human sprawl the wildlife has generally held on extremely well. There are the stories of failure; for example, the red kite, once common as a London scavenger, has fallen in numbers to a few pairs precariously surviving in central Wales only as a result of the care and energies of a dedicated group of people. But there are also successes. The roe deer has been spreading and increasing its numbers rapidly through southern England, fish are appearing again in a purer, or rather less foul, Thames, the collared dove has increased dramatically, and the numbers of grey geese wintering in Britain have improved. There is more wildlife present than the nature-blind town dweller realizes. I live on the edge of a common only 32 km. (20 miles) from the centre of London and yet herons and mallard visit my pond, kestrels hover overhead, pheasants, partridges, rabbits, foxes, deer and badgers live on the common, and the bird-table has a constant procession of visitors around it which include tree creepers, nuthatches, and green and great spotted woodpeckers. Nature does not need any help from man to be prolific—it merely needs to be left alone.

The Birds

In broad terms Britain is better off than most of its neighbours for birds but rather poorer for mammals. A major reason for this wealth of birds is the country's geographical situation as a major staging post in the fantastic migration that takes place each spring and autumn as millions of birds of many different species fly north to their breeding grounds in the spring, and south to their winter quarters in the autumn. These migrations are a source of both fascination and opportunity for the photographer and will repay closer study. A book which covers the subject well is *The Migrations of Birds* by Jean Dorst, published in 1962 by Heinemann. A few facts will illustrate some of the amazing achievements of birds on migration. The goldcrest is the smallest British bird, weighing only

7 g. ($\frac{1}{4}$ oz.), but many European goldcrests migrate to this country to winter here. One bird, ringed in Poland, made a journey of over 1,610 km. (1,000 miles). The speed of migrating birds is shown by a knot, ringed on the Wash and recovered eight days later in Siberia, a journey of nearly 6,440 km. (4,000 miles). Some migrating birds make 'refuelling' stops in which they break their journey for a time to recover condition. Sanderlings breed in the Arctic, in Greenland or Siberia and when they arrive in Britain have exhausted all their body fat and weigh about 50 g. ($1\frac{3}{4}$ oz.). From the work of the Wash Wader Ringing Group we know that they stay for about two weeks and by the time they leave have approximately doubled their weight. They then fly to their winter quarters in Africa, and one was recovered in Cape Town.

Birds that have just completed long flights are much more approachable than when fresh, but it would be an offence against the unwritten code of ethics of wildlife photography to take advantage of them at this time. To approach so close to exhausted birds as to force them to take flight again is, at the least, unfair, and could, in extreme circumstances, be fatal.

It is probable that some readers will be competent photographers but have little knowledge of natural history, and others will be competent countrymen but photographic ignoramuses. I hope, therefore, that the photographers will bear with me when I make rather elementary observations on equipment, and the countrymen contain their impatience when I explain that migration is the reason why it is useless trying to photograph cuckoos in December or pink-foot geese in Lincolnshire in June.

Major Influences

Migration is not confined to birds, for many creatures, from lemmings to whales, migrate. The reasons vary, but are concerned with either food, shelter or reproduction. It is essential for the wildlife photographer to bear these three major influences in mind for not only do they, either individually or collectively, cause migration, but they are prime factors in the behaviour of wildlife at all times. It is only by relating them to the time and circumstances in which you find yourself that you can make a reasonable pre-diction as to where you may expect to find a particular species and

what it may be doing. As human beings our lives are subjected to a considerable number of obligations, duties, temptations and influences; we are hardly ever free to wander as we choose. But if we are to understand wild things and anticipate, as distinct from simply follow, their movements, we have to strip our minds of all these extraneous pressures and try to see the world through their eyes and consider only the factors they consider. This is a convenient point to explain that wild creatures do not think as we think. By this I mean that they cannot reason. Their brains are controlled, or ordered, by instinct, reflexes and experience. Although a red deer will flee the instant it sees the stalker it does not do so because it is afraid of being shot; it cannot even anticipate death let alone comprehend the function of a rifle. But it does know from inherited instinct and experience that some sights are normal and some are not, and the latter cause alarm which triggers off the reflex action of flight. Once you appreciate the inability of wild creatures to reason, it becomes easier to understand and forecast their behaviour.

As there are no other factors to influence them you will readily understand my earlier statement that virtually every move of a wild creature is determined by food, shelter and reproduction, and to these we can sometimes add a fourth—fear. At the relevant time of the year reproduction is by far the greatest influence, and the most obvious example of the wildlife photographer taking advantage of this is the nest photography of birds. Practically all wild things are more approachable when breeding, partly because the young being usually immobile the parents have to return constantly to a fixed spot, and also because in their anxiety to tend their young the parents will tolerate a nearer proximity of humans. It takes experience to know how much disturbance a wild creature will take before it deserts its young for good, but when in doubt play safe and keep away. No picture will give you satisfaction if every time you view it you recall that its production cost the lives of the subjects. Under the Protection of Birds Act 1967 (or, more correctly, the Protection of Birds Act 1954, amended in 1967) the law is very strict on the question of the photography of some birds at the nest, and this important aspect of wildlife photography is fully dealt with in the Appendix on page 145.

In general most wild creatures will tolerate being disturbed near

their young. If you work quickly and quietly, avoid touching the young or their surroundings, leave as soon as possible, and *do not come back*, all will be well. Maternal instincts will bring the mother back, but nearly all wild creatures will desert in the face of constant disturbance.

The next most compelling influence, and one which is constant all the year round, is food. As reproduction is of limited duration, and shelter is given a lower priority than food, a knowledge of food sources and feeding habits is invaluable. Food sources can be either natural or man-made. Examples of each are the seeds from the wild salt-marsh grasses that are lifted by the tides sweeping, twice daily, up the estuaries; and the corn left lying on the surface as the farmer's drill clatters about the spring sowing. The more man farms intensively the more the wildlife in an area relies on his efforts. For example, a Cambridge wood pigeon may live off the clover leys in January and February, eat the newly sown peas and beans in March, glean the pickings from the corn drill in April, take its pick of various crops through the summer, rear its children in the days of plenty from the July and August cornfields, pick over the stubble in September and October, eat kale in November and take its first wild food of the year in December from the fallen acorns. At the other end of the scale the grouse in the lonely hills will live exclusively off the wild heather and a few grasses.

We arrive then at a basic rule of free-range photography: if you want to find a particular species find its food source. An alternative, but equally productive, approach is to find a good food source and then photograph what you find there. I do want to stress that part of the fun of the hobby is using your initiative and imagination, and pitting your wits and skill against wild things which are less intelligent than you but have better eyesight, hearing, and, usually, greater speed of flight. Good food sources are not simply farmers' crops or a hill of blueberries; there is much scope for imagination. I have an old oak which each summer discharges a stream of sweet sap which lures wasps by day and the most wonderful assortment of moths by night. And before devoting hours of the night to yet another badger photograph have you ever seen a good shot of a worm pulling a rolled leaf down its hole prior to devouring it? Or a dragonfly hawking insects along a stream?

As success depends upon knowing the habits of the quarry it

becomes essential to study their natural history, and one of the many advantages of this absorbing hobby is the knowledge of wildlife that you automatically acquire. A book I would strongly recommend is the *Shell Natural History of Britain* edited by Maurice Burton and published by Michael Joseph. For birds the Reader's Digest/A.A. *Book of British Birds* is good, and I would also recommend *A Field Guide to the Birds of Britain and Europe* by Peterson, Mountford and Hollom, published by Collins, and *The Hamlyn Guide to Birds of Britain and Europe* by Bruun and Singer, published by Hamlyn.

Although I have stressed that food takes priority over shelter this is not to say that it enjoys complete priority. Wild creatures are extremely hardy but in unpleasant conditions they will accept an inferior food if it is situated in a more sheltered setting. As an example, pheasants will not pick corn off stubble in a cold wind and rain when they can scratch for acorns in the warm heart of the wood. Extreme weather conditions are useful, for they often concentrate wildlife into the obvious places and sometimes make a close approach possible. But once again you must be scrupulously fair. Imagine, for instance, large numbers of wigeon on a fresh-water marsh grazing on small areas of grass showing through a carpet of snow. If you approach too closely and put them off to the safety of the sea you force them to use up much needed energy and deny them feeding time. You will shortly be indoors with a hot fire and a meal. They have to fight the cold for days and possibly weeks before the weather eases. Life outdoors is harsh and cruel and we must not add to their burdens.

Severe winds will send wildlife to the lee side of hills, fences, walls or any other solid protection. Frost, which will freeze the fresh water meadows but leave the salt water of the estuaries untouched, will bring large numbers of wildfowl out to the coast. In deep snow hares will dig holes in the drifts, and in the absence of quiet woods the fox will take to the kale fields. At all times the wild things seek the best shelter available to them, and, if we think, their location is often obvious. Even in mild conditions the movements of wildlife are still conditioned by shelter, or perhaps comfort is a better description. The Scottish red deer provide an excellent example being driven to the lower ground by the winter weather, but when the flies and midges begin to bite as the weather warms they return

once more to the higher ground. And so we end this chapter as we began, with migration, for this annual movement of the deer is a mild form of migration.

To sum up: to find your subjects you must put yourself into their world and think only of the basic factors of survival—food, shelter and reproduction.

2

Getting on terms

The previous chapter was mainly devoted to the question of deciding where our subjects may be found—this one is concerned with how to get as close as possible. It is no exaggeration to say that the art of wildlife photography is managing to position yourself as closely as possible to the subject. Having done this the photographer will sometimes deliberately reveal his presence, for instance, to obtain an action shot of a flock of geese rising, and in others—ordinary nest photography from a hide is a good example—will remain hidden for long periods. But whatever the final tactics I cannot overstress the fact that if you want good wildlife photographs you must solve the problem of getting near. Failure will only result in a shot of a large area of sky or grass with a small dot in the middle which represents the quarry beating a rapid retreat.

Many species will allow a close approach when young. A good example is the shot of a leveret among wild flowers (plate 1). The usual reaction of young wild creatures to danger or the unknown is to remain motionless, and this young hare allowed a close approach. Once young wild creatures develop both their legs or wings and their fear of man they take refuge in flight. As with people, the reaction of wild things is not uniform but varies among individuals and some are less wary than others. Reaction also varies with their experience. Hooded crows in sheep country, where any man with a gun will shoot on sight, will not tolerate an approach nearer than several hundred metres. Hoodies feeding on the rubbish tip near a village where they are tolerated may accept you within 9 or 14 m. (10 or 15 yards) provided you show no interest in them.

Having earlier criticized static hides on the grounds that it is a dull pursuit I must concede that this technique will, on most occasions, yield more certain results. Therefore, no book on wildlife

photography would be complete without a detailed description of hide work.

A hide is exactly what the name implies: a structure designed to shield the photographer from the view of his subject. The manner and form of the structure will vary with the job it has to do, and whether it is a temporary or permanent structure. It can be built from local materials, or be a device of poles and cloth transported from site to site as you desire. I have an excellent example of a permanent hide built on the shore of the west coast of the Isle of Skye where a small river flows into a sea loch. It is an isolated spot, popular with herons, mallard, black-backed gulls, buzzards and hooded crows. Seals bob at the entrance to the river and the occasional stoat hunts the tide wrack. My hide is built of the rocks that litter the shore with a roof of drift wood covered with seaweed. It is waterproofed by a plastic agricultural sack pinched under the roof, and a plank across two rocks makes a seat. The lens peeps through a slit in a hessian screen, and when I am absent this space is filled with a beer can to simulate the lens.

Portable hides are used where the opportunity is transitory and the need for cover only temporary, a classic example being a bird's nest which may be empty within a week or so. They can be purchased ready made, but the construction is so simple this is hardly worth while. The main components are four upright poles, which can be either wooden or metal. Electric conduit tube is ideal, being strong but light and one end can be flattened to facilitate driving into the ground. Four spacers at the top, possibly strong wire rods with ends bent through a right angle to slip into the tube ends, complete the basic frame. The size should be no larger than necessary, but should permit you to sit down without causing suspicious movements and bulges on the walls. Tent guy ropes from the four top corners are essential to secure the hide in a wind. The covering material should be opaque, for any discernible movement within, no matter how indistinct, will cause alarm. Hessian is not opaque enough but a thin canvas is good. Plastic sheeting is light and waterproof but makes alarming noises in a wind or rain. A roof is essential for all bird photography. There are many variations of portable hides, both in design and materials, but the essentials to observe are lightness, rigidity and an opaque cover. As a portable hide is usually a new and obvious blob on the landscape there is no point in going to

immense trouble attempting to camouflage it. It is sufficient to select a basic green or brown material and spray it with irregular blobs of the alternative colour. Hanging it outside for a few weeks will get rid of the newness and any smell.

Hides have sometimes to be built in very awkward places and one's ingenuity is often strained. Nests in high treetops can sometimes be covered by hides built in adjoining trees, but where this is impossible the solution is to construct a pylon hide of poles or scaffolding. The beginner would be well advised to gain experience on less ambitious projects. Hides constructed to cover the nests of water birds will often be sited on soft ground and some planks or an old door will be useful as a base. In extreme cases a raft can be made from timbers lashed across old oil-drums. With permanent hides a great range of materials is feasible, but where possible it pays to make them unobtrusive and to use local materials which will blend well with the surroundings. The reason is that a portable hide is usually placed where the quarry has to come, for example, a nest, whereas a permanent hide is situated where wildlife is likely to come but may not if there is any feature which disturbs it. Old disused buildings or abandoned agricultural machinery are ideal sites.

One of the problems of nest photography is that if the hide is erected in one operation the birds will almost certainly desert. The alternatives are either to erect the full hide some distance away and move it nearer daily, or to start the construction at the correct spot for the hide and build it in small stages. Whichever method is adopted it is wise, after each step to watch the reaction of the birds through binoculars and if they do not rapidly accept the changed situation then the last act must be reversed. The main consideration must always be the welfare of the subject, and if you find an obviously sensitive pair it is best to leave them in peace. No attempt should be made to erect a hide until the young have hatched. If the work is begun shortly after and spread over several days the young should have reached an interesting and photogenic stage by the time photography begins.

One of the strangest sites upon which I have ever constructed a hide was the top of the tower of Epsom College, to cover a kestrel's nest, and a description of this will give a useful, practical illustration. The confined space meant it was physically impossible to erect the

full hide at a distance and move steadily nearer. Hawks being notoriously shy I began by simply laying the poles and a tarpaulin inconspicuously in a corner. The next morning I leaned two poles against the inside of the parapet wall and draped a small section of tarpaulin over it. It was the third morning before I displayed any tarpaulin within view of the nest and then only a small section. Exactly a week elapsed before the hide was ready to occupy. They were, incidentally, the most infuriating subjects, for often more than two hours would elapse between visits, and when a bird, almost always the female, arrived with food, she would alight, throw the dead bird or mammal into the nest hole and depart at once. The visit was frequently over in two or three seconds and unless I remained constantly alert the chance was missed. A good illustration of the unwariness of young wildlife occurred when the young left the nest and would perch on the tower quite indifferent to the occasional sound or movement from within the hide. See plates 8 and 9 for photographs of the adult and young kestrels.

It is important to take a companion with you to the hide who will walk conspicuously away once you are inside. This will deceive the parents, who cannot count, into thinking the coast is clear, for otherwise they would not return. Equally, if you suddenly emerge at the end of the day the resultant shock will cause the birds to grow very suspicious of the hide. Your companion should return, at a pre-arranged time, or signal, conspicuously but slowly, so the parents can slip away quietly and without alarm. Only when they are out of sight should you emerge.

Nest photography, as I wrote earlier, tends to produce unoriginal photographs, and there is much scope for siting hides in other places where wildlife is likely to pass. Examples are a hide by a track in a wood inhabited by roe deer, a drinking and washing place for wildfowl where fresh water meets salt water, or a wader roost. The latter is usually a shingle bank where the waders of an estuary assemble in their hundreds, and sometimes thousands, when the flooding tide drives them from their feeding grounds.

Baiting

A useful technique for attracting the quarry to a hide is baiting—that is the systematic laying of food so that the subjects grow into

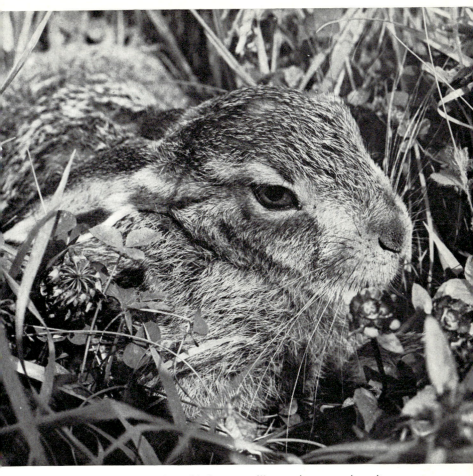

1 Young creatures, such as this leveret, will sometimes remain quite
still rather than flee and give excellent chances for close shots.
(See page 27)

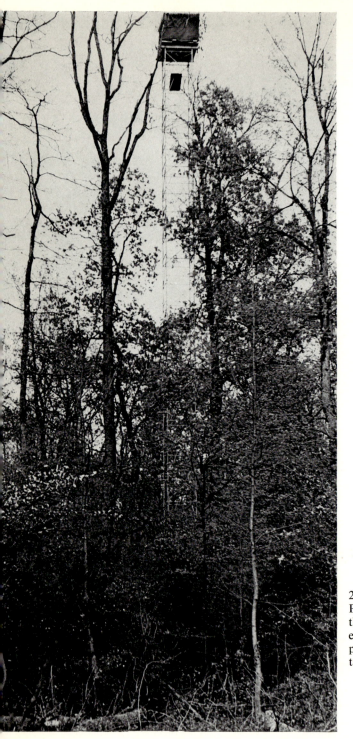

2
Possibly the highest (if n◌
the most dangerous) hide
ever built for wildlife
photography. For a whit◌
tailed eagles nest.

the habit of making regular visits to the spot. The principle is well illustrated by the ordinary garden bird-table. Many varieties of food can be used to attract a wide range of quarries; for instance, a dead rabbit, laid on its back so the white fur of the stomach is clearly visible at a distance, can attract anything from a crow to a fox. Carrion should either be tied into position or staked in such a way that the tethering device is not visible from the camera. If it is not, the quarry, in its efforts to tear off morsels, may quickly pull it out of reasonable photographic range or behind an obstruction.

Free-Range Photography

I described earlier free-range photography as hunting with a camera, and all the practices and cunning of the conventional hunter are necessary. Naturally your dress must be inconspicuous but I deal with that in the next chapter. Success depends upon spotting the subject before it spots you, and this means moving slowly and quietly and keeping your eyes very wide open. Many of my happiest days in the country with a camera have not been devoted to the pursuit of any particular species but merely roving quietly about to see what I could find. Some subjects, for instance an adder or a lizard basking in the sun, do not call for a high level of stalking skill, but others, say a roe deer browsing along the edge of a wood do. The man who stamps along, looking neither to left nor right and perhaps talking loudly to a companion, will see little or nothing. Watch an old countryman with a gun looking for something for Sunday's lunch. Note how he never walks on the skyline but keeps to the valley or the shady side of a hedge. And when he emerges from a wood or looks around a dry stone wall he does so very slowly indeed, freezing instantly if he even suspects wildlife. Very few town dwellers use their eyes or ears in the country—the slot of a deer in the mud by a stream goes unmarked, as does the alarm call of a blackbird, or the flock of pigeons which have taken fright at something three fields away. One of the joys of this hobby is that you can spend a most enjoyable day in the country and never once release the shutter.

Using Beaters

As an alternative to your going to the subject it can be brought to

you by using friends as beaters—the name given in sporting terminology to the men whose job it is to beat, or drive, the quarry towards the guns. I recall once holing up in a drainage culvert on the Isle of Sheppey to shelter from a snow storm in the bad winter of 1962–3. As it eased and finally cleared I spotted two friends coming to join me. They were over one and a half kilometres away and simply black dots on the snow. When they were still well over three-quarters of a kilometre away the wild things of the marsh began to move quietly away before them. First a hare loped slowly up a ditch. Then a covey of partridges glided past to pitch across a wide creek, to be followed by a cock pheasant trotting by with his head held low. Without haste or panic the marsh slowly emptied and when my friends joined me twenty minutes later they had seen nothing. This wariness of wildlife can be put to good use if you can hide yourself in the right spot and persuade some helpful and sensible friend to follow your instructions carefully. An example of this technique is the running hare (plate 10) which was photographed at a Cambridgeshire hare shoot where the beaters drive in hundreds of acres of countryside. In the early spring of the year in which I write this I took an excellent series of colour shots of whooper swans on the Isle of Harris in the Outer Hebrides. My family and I spotted them on an isolated fresh-water loch in the hills, and by making a long detour I was able to reach the rocks at the upwind end of the loch without being spotted. The family then converged on the downwind end from all sides, whereupon the whoopers rose into the wind and flew over me.

Stalking the Subjects

Assuming that you have discovered an unsuspecting subject you should stalk it in exactly the same fashion that a sportsman will stalk a deer with a rifle; the only difference being that whereas a hundred metres is near enough with a rifle it is no more than promising with a camera, at least in still photography where the optics give less magnification than in cine. The photograph of a red deer (plate 11) was taken by this method. A careful assessment of the route before beginning the stalk pays dividends, for where there is only one route it is vital to make sure you know it. A route which appears obvious when, for example, you are standing at the

foot of a rock strewn hillside, looks very different half an hour later when lying on your stomach in a small gully and half-way up. Points to watch for are scent and sun. A whiff of man will scare many creatures—deer are particularly touchy. Sun is important for two reasons: photographically you do not want to be shooting into it, and tactically with it behind you are less likely to be spotted. Having started a stalk keep out of view and do not keep peeping at the quarry. Nearly all wild creatures have excellent eyesight, and every time you expose even a small portion of your body you risk frightening it. When you must peep raise your head in infinitesimal stages behind grass, or other cover, and if there is none at the critical point pluck a handful of grass and hold it in front of your face. It is unlikely that I can persuade you to follow my practice when wildfowling of starting the day by wiping a handful of mud over my face; the white blob of the human face is very obvious over large distances. It is very frustrating after a long stalk to find the quarry has gone, and it pays to have a companion at a distance who can whistle you if it flees, thereby probably saving you from some minutes of uncomfortable progress.

If the quarry is feeding, for instance a gaggle of grey geese grazing (geese on the ground are a gaggle—in the air they become a skein), you should direct your stalk not towards where they are but to where they will be. A difficult stalk can easily take half an hour and in this time they may have moved a considerable distance. Where there is no possible route for a stalk a photograph is still possible if you plan ahead and have a companion to help. Ducks disturbed from a field will always head for the nearest large area of water; red deer will move away uphill; a fox will head for the nearest good cover. If you can anticipate the movements of the quarry, and arrange with your friend not to disturb it until a pre-arranged time you may sometimes contrive to be hiding as they pass.

Working from a Vehicle

A technique used increasingly in wildlife photography is working from a vehicle. This is, in effect, a form of mobile hide, and particularly so if the occupants sit still and avoid pressing large white faces against the windows. This technique can also solve one of the major problems of the cine photographer of combining camera

steadiness with mobility. As I mention in the first chapter wild creatures cannot reason, and their relative indifference to vehicles is, I suppose, due to their inability to understand that people, whose form they recognize as dangerous, can be inside that big square object whose presence they do not regard as dangerous. As on foot, so in a vehicle, slow progress pays, not only because you have more time to see but because when you do spot an opportunity there is no need to halt abruptly, which action scares even the less timid creatures. The more wary will often depart as soon as the vehicle stops, and others which will tolerate this leave when the engine is switched off. It is therefore sensible to have the camera ready for immediate use, and to leave the engine running until just before you release the shutter. For reasons of road safety the practice of pottering slowly along and stopping, for no purpose that the average following driver can foresee, is dangerous. Therefore vehicle photography should be restricted to quiet, little used, roads, which are usually the best for wildlife anyway. The ideal is a Land-Rover along farm tracks or even where the ground permits, across open country. In my own Land-Rover I have removed the central front seat and padded the resultant hole with foam plastic sheet for storing the camera in the ready position. Perfection is achieved by having a sympathetic driver and sitting, with the camera at the ready, in the back row of seats with the windows already open. This allows you to take opportunities on either side. It is useful to fit blinds to the windows so you can use the vehicle as a static hide if necessary.

3

Comfort and survival outdoors

The enthusiastic wildlife photographer will pursue many different species in a great variety of habitats and in all conditions of weather. The townsman who ventures into the countryside only when fine weather lures him, and then only for short spells, has little idea how savage nature can be, and only the occasional loss of life on high ground serves to utter a vague warning. Even in the summer on low ground it is possible to be uncomfortably cold, so dressing correctly is essential at all times if the day is to be enjoyed and, in extreme conditions, may make the difference between life and death. In practice you will rarely go out in extreme conditions for at these times photography is rarely practical, but on the hills conditions can change very rapidly and it is all too easy to be caught. I once climbed Ben Buie on the Isle of Mull in March to photograph ptarmigan before they lost their winter plumage. The day was fair and the forecast reasonable but within an hour of reaching the summit plateau a blizzard began. With visibility down to 9 m. (10 yards) in the snow I was soon forced to shelter behind a large rock. The storm blew over after two hours but had it continued until dusk I would have been in considerable danger without proper equipment. However, extreme conditions are rare so let us begin with normal conditions.

Footwear

Wildlife photography frequently involves walking considerable distances and often over rough country. Ordinary shoes are inadequate for all but the easiest conditions as they let water in easily and offer no ankle support. A medium-weight pair of good quality leather boots are far more comfortable for walking than wellingtons,

although the latter are best for really wet conditions. If you must wear wellingtons it is now possible to buy lightweights. Never buy a pair of boots and wear them for the first time for a long walk. The penalty will be blisters, and the wise course is to break them in by degrees by wearing them to mow the lawn or other local activities. On long walks take some sticking plasters and cover even a trace of a blister immediately it appears. Buy boots a size larger than your shoes and wear either a thick pair of socks or two thin pairs. All this may seem rather fussy, but once blisters develop they can seriously curtail your mobility and remove some of the pleasure of being outdoors.

External Clothing

The first consideration for external clothing is that it should be inconspicuous. Whether it is green or brown matters little, for you will wear it in many places and no colour will be right at all times. Take care that the colour is dull and the material non-shiny. Remember that movement attracts attention more than colour. The remaining duty of external clothing is to keep you warm and dry and as, taking the year through, keeping warm outdoors is a major problem we will consider for a moment the principle to follow. The lead is given by wildfowl which have to survive some of the coldest and wettest conditions of all wild creatures. This they do with a thin outer layer of waterproof feathers protecting a thick insulating layer of down containing innumerable air pockets. In our case we need a thin but waterproof jacket or coat under which we wear as many insulating layers as the day requires, or on warmer days simply a shirt. On hot summer days, when any form of jacket would be a curse, I tie a thin plastic mac, tightly rolled, to my belt. This precaution is sometimes a blessing when your travels take you a long way from shelter. It is surprising how difficult it is to buy a really waterproof coat. The waterproofed cotton jackets made by Barbours of South Shields are good, and some of the new nylon materials are both waterproof and light. Ordinary plastic materials are too shiny, often noisy, and, because they do not breathe, cause sweating. Always ensure the jacket has ample length and a hood. Waterproof trousers make walking a burden and have a short life. The best solution is a light nylon pair kept in a pocket until needed.

The Inner Layer

Various new forms of internal clothing have been devised, each claiming to be warmer than the others, but I find wool clothing as good as anything. Avoid on cold days the mistake of wearing a vest, a shirt and two pullovers above and just a thin pair of trousers below. Long woollen pants may lack dignity but outdoors in January dignity takes a low priority. In hot weather shorts are inviting but are usually a mistake. On low ground your legs are torn by brambles and on high ground rasped by old heather or rock. Wherever midges are prevalent a tube of fly repellent is a blessing.

Route Finding

Whenever you are on unfamiliar ground, and particularly in isolated country where people are scarce, a map is important. I use the 1:50,000 (1 in.) Ordnance Survey, which is sufficient for all normal purposes and inexpensive. This serves not only to find your way but a careful preliminary study will enable you to plan the route most likely to hold wildlife. In fact whenever I visit a new area I spend some time beforehand marking up a map with spots worth investigating. A compass is another essential, for a map alone is useless if a mist comes down, or if you are caught out by dusk. This latter threat is lessened by a sensible preliminary appraisal of what you are trying to do and how long you have to do it in. A year ago I set out to walk along the shore of an isolated part of the Outer Hebrides, intending to rendezvous with my wife where a small road met the coast some 10 km. (6 miles) further on. As I had over three hours before dusk there seemed ample time, but I had failed to study the map carefully and had not realized that a series of hills descended into the sea loch, finishing as fairly severe cliffs. To pass these I had to toil up each one, away from the water, until the angle slackened, and by dusk I was still 3 km. (2 miles) away from base with some extremely dangerous walking ahead. Unequipped the position would have been serious, but I was able to identify my position on the map, spot a small hill road 2 km. inland, take a compass bearing and reach it across the moor before the light failed completely.

Survival

When I now turn to more extreme conditions many readers will feel the advice irrelevant to them as they have no intention of being out in severe weather. But this is precisely the reason why people are unprepared; hardly anyone intends to face extremes; it just happens that by a trick of circumstances they suddenly find the situation has arisen. While you can find yourself in trouble on low ground in severe weather it is the hills which are the real killers. Down below one is never very far from a road, dwellings or people, but on the tops, where the winds have free play, the weather can change suddenly and dramatically. It is a very cruel world. Nor are the hills to be treated lightly in the summer for a slip could break a leg or an ankle, and a night on the tops could be fatal to a wounded man or one in poor condition. The villain is hypothermia—the condition when the body loses heat faster than it can produce it. In really severe conditions an inadequately clothed but otherwise fit man can be dead in a couple of hours. It is a mistake to attempt to wear an excess of warm clothing for you will rapidly overheat whilst walking. The spare clothing should be carried in a waterproof plastic bag, and with it I always pack a small first-aid kit, a whistle and some waterproof matches. Additionally I follow the latest trend in mountaineering thinking and carry a 244 cm. × 122 cm. (8 ft. × 4 ft.) heavy-gauge polythene bag. This weighs less than 226 g. ($\frac{1}{2}$ lb.) but is invaluable at keeping the wind and rain out and the heat in if you have to shelter for prolonged periods. By the time I have added some photographic equipment and food this adds up to a modest load and the right way to carry it is in a small rucksack.

Oddments Towards Comfort

Gloves are obviously essential for the extremities are the first to suffer from cold. It is almost impossible to operate a camera quickly whilst wearing gloves but removing them takes time. A good alternative is mittens, which leave the fingers free but cover the backs of the hands and wrists. A device I have found very effective and a great comfort is a metal hand-warmer which costs about £1 and burns ordinary lighter fuel. It is no larger than a packet of cigarettes but gives a cheerful flow of heat for hours. There is also a more modern alternative which burns a bar of solid fuel.

The neck needs careful attention, for every movement of the body pumps valuable heat through any gaps. A silk scarf is effective, and when combined with a woollen ski-cap and the hood the improvement is marked.

The final precautions are to leave a note of your route whenever you venture on to isolated ground, and whenever possible take a companion.

Section Two

STILL PHOTOGRAPHY

by John Marchington

4

Equipment

A few forms of wildlife can be successfully photographed with a simple camera, a hedgehog is a good example, but most species present formidable difficulties which cannot be overcome without the right equipment. This does not necessarily mean equipment that is either expensive or complex, but it must be capable of coping with the problems. The selection of the right camera and accessories is therefore of paramount importance, and the best way to decide on the essential features is to consider the work the equipment has to do.

It must be capable of reproducing small distant objects to a reasonable size on the negative, or alternatively carrying out very close work on, for example, a dragonfly. (See plate 14.) The shutter should be fast enough to arrest the movement of a bird travelling at possibly 97 km.p.h. (60 m.p.h.) yet so quiet that it does not create a disturbance in hide photography at a nest. The negative size should be large to permit good enlargements without grain or loss of sharpness yet the equipment should be light for carrying over rough country. The viewfinder must permit perfect focusing, eliminate parallax and allow a fast moving subject to be followed with ease. There are other desirable features but these are the essentials that really matter and the unfortunate fact is that no camera exists which satisfies all these requirements. Your choice will be a compromise, and your personal selection will be influenced by the branches of wildlife photography you expect to follow.

Nor is there a simple answer to every specific requirement. I will deal with the essentials listed above in detail and consider the various solutions with their good and bad points.

First, and very definitely the most important, is the need to reproduce small, relatively distant, subjects to a large size on the

negative. The major problem of wildlife photography is summed up in the world 'wild'. The subjects are *wild*, and in the great majority of cases will not permit a close approach. The problem is intensified by the fact that the science of optics is such that close objects appear unnaturally large and distant objects excessively small. A long focus or telephoto lens is therefore essential and if this is to be fitted the camera must have provision for lens changing. This facility also provides, in some systems, the solution to close-up photography. Whether the lens is attached to the camera by a screw or bayonet fitting is not terribly important. The latter is quicker, and therefore better, but costs more. The form of lens used cannot be described briefly and I will deal with this later in this chapter.

This is a convenient point at which to explain that the difference between a long focus and a telephoto lens lies simply in the design and construction. By using a negative lens as the rear component a telephoto lens can be made lighter and smaller than the equivalent long focus lens.

The ability of a shutter to stop fast movement is determined by the maximum fast speed it will permit. 1/500 second is useful and will cope with many situations, but inevitably you will sometimes have more demanding subjects and require a 1/1000. You should only settle for 1/500 second if you expect the great majority of your work to be with stationary or slow moving subjects. Shutters fall into two basic types—focal-plane shutters and lens shutters. With the focal plane a blind with a slit in it travels across the surface of the film, the slit varying in width according to the exposure time selected. The blind protects the film from fogging when the lens is changed. This system is excellent and very well proved, but has the considerable disadvantage of being noisy. The lens shutter operates by moving blades and is very quiet but, for reasons of design, is not manufactured to give shutter speeds of more than 1/500 second. The ardent nest photographer, where quietness is more important than arresting movement, will select a lens shutter and the free-range man a focal plane. Cameras with focal-plane shutters can be muffled but the operation of the camera becomes rather clumsy. An alternative answer is to site the camera further back and use a long focus lens but, as we will see later, this gives depth of focus problems. There may also be sites where you really have no alternative position for the camera.

The question of format size, that is the size of the film receiving the image, is mainly determined by whether you expect to work from a hide or free range. Obviously the larger the format the bigger and heavier the camera. There are several good large format cameras, Arca, Sinar and Linhof are excellent examples, but while the quality of work they produce is much superior to a single lens reflex, and they also have a reflex focusing back, they are much too cumbersome and slow for anything other than hide work. For reasons I will give shortly, for all round wildlife photography you will need a relatively light camera with a reflex viewfinder. The maximum format in which such a camera can be obtained is $2\frac{1}{4}$ in. square. The smaller and lighter 35 mm. will be adequate on most occasions, but if you hope to have some of your colour work published you will find that most publications prefer to work from the larger $2\frac{1}{4}$ in. square format. Briefly $2\frac{1}{4}$ in. square gives better results but the equipment is more cumbersome.

The final essential is a satisfactory viewfinder. Many opportunities in wildlife photography are fleeting and if not seized at once will have gone for good. Rapid focusing is therefore essential and because the depth of focus of a telephoto lens is limited the focusing must also be accurate. For close up work parallax is also a problem. The only practical solution is a reflex camera. Most readers will know, and almost certainly use, this system but for the benefit of the few I will explain that the image projected through the lens is intercepted by a mirror set at 45°. This throws the image upwards on to a ground-glass screen which is precisely the same distance from the lens as the film. When the focus is adjusted so the image is sharp on the screen it will also be sharp on the film when the exposure is made. For a really detailed analysis of the workings and use of the reflex camera I would recommend H. S. Newcome's *Photography with the Eye-Level Reflex*, published by Focal Press.

These, then, are the essentials: the ability to change lenses, a 1/1000 second shutter, reflex viewfinder and a format size from 35 mm. to $2\frac{1}{4}$ in. square. There are, of course, many other features available with different cameras and most of them are useful. However, all devices cost money, and most readers will have a ceiling to the amount they are able and willing to spend on equipment. It is far better to have a simple camera of good quality than the reverse.

You may be surprised that I have not made a built-in exposure meter an essential. A problem in wildlife photography is that you can rarely approach near enough to the subject to take an accurate reading. Where you can, for example at a nest, it matters not whether the exposure meter is separate or not. Readings taken at a distance usually have to be made on something of the same colouring as the subject and here again having a built-in meter does not help. A further complication is that most built-in meters scan the normal field of the standard lens and give an average reading. As a result the value given for a light subject on a dark background, for instance, a mountain hare in its white winter coat among dark heather, would be hopelessly wrong. The reading would be equally wrong, but in the opposite direction, with a red deer in snow. There is one exception, which is through the lens metering. In this system only the light coming through the lens is metered, which means automatic adjustment for any size of lens. The ultimate is reached with a reading taken only from a small circle in the middle of the image. I have a Leicaflex with this facility which I often use with a 560 mm. Telyt lens. Here I can take a reading on the actual subject rather than the general view and ensure perfect exposure. Always assuming, that is, that the creature allows me the necessary time.

I would stress once more that the final choice of equipment must be made by the individual, for he alone knows what he is trying to achieve. For example, the naturalist may only wish to record, and quality may be of secondary importance. For his needs 35 mm. will be adequate, whereas the perfectionist may well be prepared to tolerate the inconvenience of $2\frac{1}{4}$ in., or even larger. A further question to debate is whether to purchase new or secondhand. Usually when buying any form of machinery I feel it is wisest to buy new, but cameras are a rather special case in that very few cameras are ever worn out. In the main they are traded in as part exchange for some new model with a few more gimmicks for, like the car industry, the photographic manufacturers must stimulate demand by changes even if the basic, and important, components are unaltered. This also raises the question of who you buy from. New or secondhand you will, in my view, do best from a well-established local dealer. He cannot afford dissatisfied customers and must firstly offer reasonable value and secondly give good after-sales service. You may strike a better bargain privately, or with

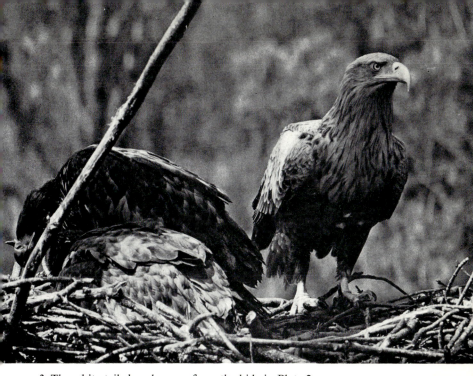

3 The white-tailed eagles seen from the hide in Plate 2.

4 A simple hide to film at a bird-table.

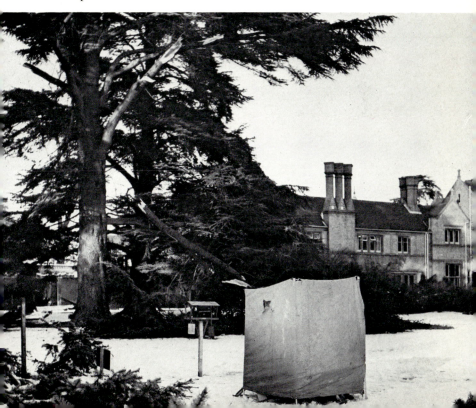

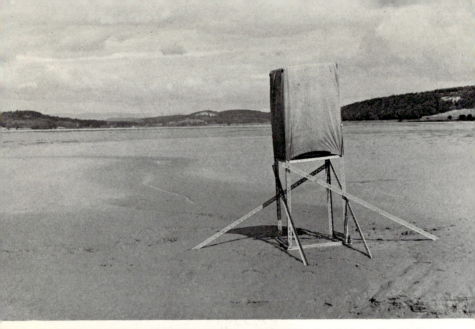

5 A hide to film birds on an estuary—not only to conceal the photographer but also in an attempt to keep his feet dry at high tide—an attempt which failed.

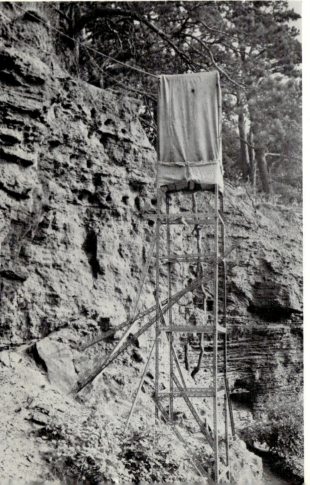

6
A hide to film sand martins at a quarry.

some distant cut-price dealer, but equally you may come badly unstuck. This pro-secondhand philosophy applies even more in the case of lenses which, with no moving parts, are, if unscratched, virtually new.

It is possible to buy a reasonably sound secondhand 35 mm. camera, which offers the basic essentials I have listed, for as little as £25. Examples are the German Praktica and the Russian Zenith. More modern models of these will probably have secondhand values of £30–50. From £40 upwards it should be possible to find second-hand models of Asahi Pentax, Petri, Yashica, Minolta and Exakta Varex. New models of these cameras range from £60–170. Moving upwards in both price and quality sees a lesser variety of makes available, but there are some really excellent cameras. They include the Nikkormat at £181, the Canon F1 at £315, the Nikon Photomic FTN at £292 and the Leicaflex SL at £605. 35 mm. cameras were designed for use by all classes of photographers but $2\frac{1}{4}$ in. square format cameras were intended for more serious workers. As a result there are no low-priced specimens capable of interchanging lenses of any real power. The cheapest is the Zenith 80 at £145, which is designed to look and operate as a rather large 35 mm. camera. Next up the price ladder comes the Japanese Bronica which uses Nikon lenses as standard. New it costs £373 and may be found secondhand in the £100–200 range. It is very suitable for wildlife work. Next comes the Swedish Hasselblad using Zeiss lenses. This is an excellent camera of high quality suffering only one drawback: that the shutters are behind the lens and give only maximum speeds of 1/500 second. In all other respects this camera is so suitable that if I expected to use high speeds only on rare occasions I would tolerate this drawback. New it costs £400 and reasonable secondhand models may be found around £250. Finally we come to the Rolleiflex SL66 which also uses Zeiss lenses. Although heavier than the Hasselblad it has a focal-plane shutter which permits 1/1000 second. Another feature is that the lens is mounted on a long rack arm with an extendable bellows which permits close focusing without carrying extra fitments. The sole drawback is the price—£631, and secondhand models are hard to come by.

In practice the cost of acquiring a new camera is likely to be less than the figures quoted above. These are the published retail prices, but most large dealers offer new cameras at lower figures—sometimes substantially so.

For various reasons, which I give in detail in Chapter 6, the best lens for the beginner to wildlife photography will be in the 200–300 mm. range. Remember to mate the lens and camera before buying. If you omit this precaution you may find an adapter is needed which is hard to obtain, or there may even be physical problems. I once bought an expensive adapter to fit a Zeiss lens on a 16 mm. cine camera only to find that it was impossible to focus at infinity. Most standard lenses nowadays are 'coupled' and it is only when one is denied this feature, as in the really powerful telephoto lens, that you appreciate how valuable it is. Setting the aperture in a coupled lens does not close down the iris to the value selected, the lens remains at its full aperture to allow the brightest possible image for focusing. When the shutter is operated the iris closes to the pre-selected value then immediately re-opens. Without this it is necessary to focus at full aperture, reduce the setting manually, take the photograph, and finally re-open the lens. This obviously takes longer and time in wildlife photography is often critical. Coupled lenses are available in many lenses below about 300 mm. and are worth paying more to obtain, although once more I would stress the philosophy that, if money is limited, simple and good is best.

The cheapest new lens in the 200–300 mm. bracket that will give acceptable results will be in the £30–50 range. Secondhand specimens may be obtained from £20 upwards. Typical reliable makes are the Japanese Hanimax and Soligor, or the German Meyer. These lower-price lenses are not coupled, and to buy a lens with this facility will mean paying, for a new lens, from £60 upwards. At the £60 level a coupled 300 mm. lens with an aperture of $f4\cdot5$ can be found in such makes as Hanimex, Derek Gardner and Soligor. The best, but most expensive, lenses come from the camera manufacturers. Typical good makes are Pentax, Minolta and Nikon, who produce lenses, mostly coupled, in the 300 mm. range with apertures of about $f4$ for prices ranging from £200 upwards.

With all lenses you pay not just for the powers of magnification and definition but for the maximum usable aperture. I stress *usable* as the larger the aperture the poorer the definition, and poorer quality lenses will sometimes offer an aperture at which the results are unacceptable. In wildlife photography large aperture settings are important, for moving subjects demand fast shutter speeds. We are then driven into the expensive corner where the ideal lens will have

both high powers of magnification and a large usable aperture. However, definition is more important than either of these two features, and if with limited money you buy a lens which promises more than can reasonably be expected at the price then the definition is unlikely to be good.

Optional Equipment

There are many other items of equipment available and most of them never leave their neat little cases once the novelty has worn off. However, the following items will be very useful on occasions:

TRIPODS: For hide work, and on rare other occasions, a tripod is essential, but for free-range photography it is cumbersome to carry and the time taken to set it up will lose many a chance. When you buy one avoid the lightweight, slender structures. There is no such thing as a really steady light tripod—it has to be heavy.

SHOULDER BRACE: The more powerful, and therefore heavier and longer telephoto lenses, are extremely difficult to hold steadily whilst focusing. Various designs of shoulder braces are marketed which are shaped like a gun stock. One end beds in the shoulder and the other attaches to the camera, usually screwing into the threaded hole designed to take the tripod. This simple, inexpensive device works effectively.

TROMBONE FOCUSING: A further refinement is a trombone focusing attachment in which the lens is coupled to the camera by two tubes, one sliding within the other. This permits far more rapid focusing than can be obtained by conventional methods. This system is standard for the Telyt telephoto lens which fit the Leicaflex and one can be seen in use in plate 16.

MOTORIZED CAMERAS: In this system the procedure of winding on the film and re-setting the shutter, which would normally be performed by hand, is carried out automatically by an electric motor, powered by batteries, which is triggered off when the shutter is operated. The mechanism can be set to operate for simple exposures or will operate continuously, taking exposures rapidly, until the shutter button is released. There are two useful applications for the

49

wildlife photographer. For moving subjects the camera can be set on continuous operation and allowed to fire away while you concentrate on focusing. The chance of getting a frame or two in focus is obviously better than if you are restricted to the usual single exposure that time normally permits. The second application comes when the camera is set up near a hide or bait point and operated from a distance by remote control. The control can be as sophisticated as radio or as primitive as a length of string passing through staples in convenient branches. The problem with motorized cameras is that they are expensive, both in the initial cost of the equipment and their subsequent frightening appetite for film. Additionally they are heavy to carry, and for hide work, noisy unless heavily shrouded with sound insulating material. There is one further disadvantage which applies equally to all complex extras. Wildlife photography is inevitably done in the country where there is little chance of obtaining skilled attention in the event of a breakdown. The more moving parts the more chance of trouble.

FILTERS: The wildlife photographer uses filters to a far less extent than the all-round photographer. To a great extent this is because in free-range wildlife photography there is rarely time to select and fit a filter even supposing any good can be achieved by using one. Another problem is that most filters have the effect of requiring an increased exposure, and on moving subjects one is often already stretching the aperture to the limit. There are occasions when a filter can improve the result; an example would be photographing in monochrome birds flying on a day of part cloud, part blue sky. Without a filter both sky and clouds would appear white, but a yellow filter would capture a true rendering. My advice would be to restrict your filter collection to one of yellow until experience enables you to select those you really need. This philosophy may well be applied to all your purchases in the early stages.

CARRYING CASES: The need to visit wild places imposes above-average travelling stresses and risks on the equipment. In the chapter on advanced work I deal with the safest ways of carrying the equipment across country, but it is wise to see that it is well packed for transport to the area you will be working in. Some makers offer specially made cases for their models but these are expensive. I

achieve the same result with economy by buying an ordinary small travelling case of one of the new, light but strong, fibre materials. This I completely line with thick foam rubber, then position the equipment carefully on this and cut the outline with a sharp, thin knife. The surplus material is removed and a further sheet glued in the lid.

BEWARE: Buy simple but good equipment and avoid a mass of expensive accessories. As your experience develops you may well change the basic units and the trade in value of the associated accessories will be low. The time to add the extras is when you are quite satisfied that the basic units will serve your needs for some time to come.

5

Film—the raw material

Film is to the photographer what canvas and paint is to the artist, and the choice of the right materials is just as important. Whether you intend to work in monochrome or colour certain basic facts apply. There are many different makes of film available, each offering different film speeds, and the man given to indecision and a gullibility to advertisements can spend years moving from one film to the next and never really become conversant with any. As I have stressed before success in wildlife photography often depends upon thinking and acting quickly, and there is no time for pondering the features of a new variety of film. If you can settle on one film then eventually you will know its performance in all lights, and many exposure errors will be eliminated.

Choice of Film

Given the wisdom of using a specific film the problem becomes which? The simple solution is to decide on your needs and find the film that answers them. Unfortunately the needs of the wildlife photographer are manifold. However, one feature is desirable for almost all forms of our hobby and that is a fast film speed. In poor light this may be essential to obtain a photograph at all. For moving subjects a fast film will permit a smaller aperture which will increase the depth of focus, and the same advantage is useful in nest photography. At first thought the answer is to go out and buy the fastest films available, but a short digression on monochrome film characteristics will show the problem. Film consists of a flexible transparent base coated with an emulsion of silver salts and other chemicals in a layer of gelatine. This is an extremely simplified description of a most complex subject but it will serve for our purpose. Most

photographers know that the faster the film the larger the particles of silver halide in the emulsion, and when the negative is enlarged these particles give a grainy effect on the print which reduces sharpness. What is not so well known is that the faster emulsions are also thicker, which for reasons not important to this book also reduces sharpness.

As a result we are faced with the problem of losing either film speed or sharpness, and which way you veer will depend on your particular ambitions. Much of my work is published in magazines and is rarely reproduced larger than full-plate size. Therefore in my case grain is not so important. Additionally, as I made clear at the beginning, I prefer free-range photography which means fast shutter speeds and therefore fast film. You should not assume from this that if your ambition is to photograph hedgehogs or to specialize in nest photography you will be better suited by a slow film. Both these examples will be troubled by depth of focus problems where the low aperture associated with the higher speed film will be useful. In practice the rule for the wildlife photographer should be to use the fastest possible film which still presents him with acceptable grain. (A factor to consider is that grain can be reduced by developing for longer periods in a weaker developer.) Using the ASA system of stating film speeds I would say this means film in the 200–400 ASA class. For the man whose activities will rarely require fast film and who needs to produce really big enlargements there is a strong case for the 75–200 ASA range. In theory there is no reason why you should not use two speeds of film but in practice you will often have the wrong film in the camera just when a good opportunity occurs.

Although, as a result of years of experience, I am firmly wedded to one particular monochrome film, I am reluctant to name it, for I believe that there is little to choose between the best makes. However, I would recommend that you favour one of the few large, well-known manufacturers, for their quality control is likely to be superior. The only front upon which the little man can fight the giants is price, and when economies have to be made quality sometimes suffers.

Colour Film

So far I have dealt with black and white, and there is a lot to be said

for starting your career as a wildlife photographer in this medium. You are going to waste a lot of the film on creatures which are either in the centre of the negative and blurred, or sharp and on the edge with their heads cut off, and monochrome is considerably cheaper than colour. Another factor is that if you have ambitions about selling your work it is a fact that far more monochrome photographs are published than colour and the demand for the former is consequently much stronger. But in time you will inevitably move to colour and will quickly discover that the problem of film speeds is even greater than with monochrome. Some of the most popular colour films, which give the best colour renderings, are so slow as to be unusable at really fast shutter speeds even on a sunny day. In monochrome the penalty of high film speeds was grain and loss of sharpness, whereas in colour the price is inferior colour rendering. In fact this drawback is not always apparent for people's idea of correct colour rendering varies enormously. In general the slower films are 'warmer' in colour, and the faster 'colder'. While I refrained from naming my preferred monochrome film I feel obliged to do so with colour because the choice of fast colour films is so very limited. I use High Speed Ektachrome by Kodak which has an ASA rating of 160, although I find it necessary to rate it a little lower. While the colour rendering might not please the studio perfectionist the great increase of speed available over most of this film's competitors is ample compensation for the wildlife photographer. There is a home processing kit available for this film, but if you have your work processed professionally I would recommend that you insist that it is returned to Kodak. My experience has been that some of the smaller processing houses do an inferior job and are inclined to scratch the film.

Colour film requires more accurate exposure than monochrome for two reasons. The first is that it simply has less latitude for error. The second is that if you do your own processing of monochrome work, and most serious photographers will, a little careful work at the printing stage in the darkroom will often overcome an exposure error in the field, but errors in colour are less easily corrected. High Speed Ektachrome is a reversal material for projection slides. If you want colour prints you will use colour negative film but I think it unlikely that this will be your wish. A good wildlife photograph deserves showing at its best and the ideal way is to project it on a

screen. A further factor is that if you hope to have your colour work published most editors will prefer it in reversal material, although satisfactory results can be obtained from a good quality colour print.

For colour work when the sun is hidden, on high ground, or the sea, a 1A or 'Skylight' filter will restore the 'warmth' of colour which would otherwise be missing.

Home Processing

This is a convenient point to consider home processing for monochrome. I appreciate that shortage of space will make this a problem for some readers but unless the difficulty simply cannot be solved then home processing is a must. The reasons are cost and performance. When opportunities occur you will take many exposures of basically the same subject to make sure you have at least one good shot. The cost of having these numerous attempts processed in order to thin them down to one or two would be prohibitive. Nor can commercial processors, aiming at a quick and low-priced job for the popular market, devote the necessary time and trouble to producing a good job. The practice I advocated earlier of slow development in weak developer to reduce grain would be impossible for them, and the finer skills of print making have no place in what is simply a mass production printing factory. Colour film can be satisfactorily processed at home, and this eliminates the risk of careless handling I mentioned earlier.

It is not the function of this book to give advice on home processing—merely to urge the practice as an important part of producing good wildlife photographs. Beware of using poor quality darkroom equipment. There is no point in producing a sharp negative through a good camera lens and then enlarging it through an inferior enlarger lens.

6

The technical problems

For the benefit of newcomers to photography I must dwell briefly on the elementary relationship between shutter speed and lens aperture. A camera is, fundamentally, a box which both shields the film from light and holds the working bits and pieces. Opposite the film is a hole containing the lens which, when the shutter opens, projects the image on to the film. To get the right exposure the correct amount of light must reach the film, and it matters not whether the light flows for a very brief moment of time through a large diameter lens or for longer through a smaller one. This is also a suitable point to explain the system of expressing lens apertures by 'f' numbers. This is simply the number of times the aperture of the lens at a given 'f' number will divide into the distance between the centre of the lens and the film surface. Therefore $f16$ is a small aperture and $f4\cdot5$ a fairly large one.

Newly acquainted with, or reminded of, as the case may be, this fundamental knowledge, we can now move on to consider the technical problems of wildlife photography. The first fact of photographic life which weighs upon us is the frequent need for relatively fast shutter speeds. There are two reasons. The first is that wildlife is usually on the move and we must arrest this movement or suffer a blurred image. The second stems from our need to use telephoto lenses, for these magnify not only the subject but also camera shake and a fast shutter speed is essential to reduce this to insignificance. Fast shutter speeds mean large apertures if the film is to be correctly exposed, and large apertures mean very restricted depths of field. Again returning to basics the depth of field is the distance each side of the point of focus at which the image is acceptably sharp. With a standard lens the depth of field is rarely a problem, except at the maximum apertures, but the greater the focal length of a lens the

more critical depth of field becomes. As an example the depth of field of a 500 mm. lens working at its maximum aperture and close focused at, say, 6 m. (20 ft.), is measured in millimetres not centimetres. Even at 46 m. (50 yds.) or more the depth of field of a large lens may be so restricted that with, for example, a red deer standing sideways it is impossible to have the tips of both antlers in focus. With so little margin for error, coupled with the fact that the subject is often moving, it will be seen that focusing poses a major problem. It is, in fact, such a necessary technique for wildlife photography that I have devoted the next chapter to it. Depth of field is not always a problem for it can sometimes be a useful servant. The natural camouflage of some subjects means they merge into the background and are not easily photographed. Deliberately selecting a large aperture can throw the background out of focus and cause the subject to stand out sharply.

For the reader with experience in photography the problems now begin to show themselves clearly. Firstly you have the difficulty of approaching within range of a wary, and usually small, subject, and then you have to photograph it under severe technical disadvantages. The problems of photographing static buildings, trains which run on fixed routes, or even children who can be bribed into predetermined actions now seem relatively simple!

It will also become clearer why I recommended selecting a 200–300 mm. lens rather than beginning your efforts by facing the greater problems of the really powerful telephotos. These more modest lenses have a greater depth of field, are lighter and as an additional bonus usually offer a larger maximum aperture. With standard lenses it is quite rare to use the maximum available aperture but with telephotos it is common to be stretched to the limit—partly because the limit is nearer and partly because of the faster shutter speeds frequently employed. In fact on many occasions, and particularly when using colour film, you will find you just do not have the aperture you need. If you take the precaution of carrying a faster film you can use this, and tolerate the drawbacks, but if you have no alternative film, or no time to insert it, give your standard film all the exposure you can and later increase the development time. The quality of negative will suffer, but not to the point of being unusable. Under-exposed colour film can be sent for special processing, although this costs more. Beware of over-developing a roll

for the benefit of one shot and spoiling thirty-five others. These dangers are lessened by using the less powerful telephotos which offer larger apertures than their more exciting relatives. By now it will also be apparent why I was emphatic that reflex focusing was essential. By this system focusing can be done both instantly and accurately. Imagine the difficulty of estimating the range and setting it in the focusing scale with a lens where accuracy is still critical at even 46 m. distance. Moving subjects would be simply impossible.

Telephoto Lenses

As so much of your work will be done on telephoto lenses it is worth considering them in greater detail. As you gain experience in handling the less powerful lenses it will seem increasingly obvious that the answer to your problem is a lens of 500 mm. or even more. In many ways this is true, but beware of selling your well-tried lens to obtain the larger one for you will find there are many disadvantages in addition to the ones I have listed. By all means have a 500 mm. in addition to something in the 200–300 mm. range, but if you can afford only one, settle for the latter. I will briefly list some of the drawbacks of the larger telephotos. A major one is that unless you pay a very considerable sum of money the performance of the large lenses is inferior to the medium ones. Indeed, the cost of the best has leapt to the point of being prohibitive to all but rich men and professionals. For example, the 500 mm. Zeiss for the Rolleiflex SL66 is now over £800. However, a 600 mm. Solignor, which will give a reasonable performance, can be bought for £89. I explained previously that the large lenses are not coupled, and the need to manually set the aperture after focusing, combined with the cumbersome weight and length, makes them slower to use. Remember also that at any given aperture and distance the depth of field of a large lens is much inferior to a medium lens. I mentioned earlier the snag that greater magnification increased camera shake but it has the further disadvantage of reducing the field of vision. In other words the more you magnify the less area is seen in the viewfinder and this can make it very difficult to pick up the subject quickly. For instance, if a goose is flying in a sky clear of clouds it is surprisingly difficult to 'home' on to it through the viewfinder. It is easier on the ground where there are static objects to give a sense of direction.

In practice a 500 mm. is about the largest lens that can be used for free-range work, and even this is awkward to carry over rough ground and susceptible to damage. (I deal with this problem in Chapter 10.) An interesting development in recent years has been the introduction of the auto tele-plus converters which are interposed between the lens and the camera. These are optically designed to double the focal length of the lens but at the price of a much reduced aperture. As we have seen earlier in this chapter the inability to open up the lens to a reasonably good aperture can be a major drawback but as these devices can be had for something over £10 they are worth investigating for your particular equipment.

A Fundamental Rule

You may by now, and even more so if you are a photographic novice, feel mildly depressed by the technical problems. Take heart —logically there is a simple answer which, if followed, overcomes the difficulties, so far as they can be overcome, and allows you to concentrate on the essentials. *Always use the slowest shutter speed possible.* If you think back over this chapter you will remember that the two problems are focusing and depth of field. Improving the depth of field automatically helps to eliminate any small error of focus. The depth of field is improved by reducing the aperture, and this occurs when you decrease the shutter speed. Therefore, if you always use the slowest possible shutter speed you improve your chances of a good photograph as far as you possibly can.

Shutter Speeds

Given this useful fact the next question is to determine what is the minimum usable speed for the various situations you will encounter. The first point to appreciate is that the problem is often not so much arresting the movement of the subject but the camera. Men who have only worked with standard lenses frequently have a shock when they find just how difficult it is to hold a powerful telephoto lens steady. On a hand-held 500 mm. you should never go below 1/500 second unless the lens is firmly rested on a rock, vehicle or similar solid support. (In a vehicle always turn off the engine before exposing.) Even then 1/250 second is slow enough and you would be wise to

duplicate at 1/500 second if the subject permits. On a lens of under 200 mm., 1/250 second is possible if hand-held very steadily, but as the depth of field is better there is often no point in trying and it is safer to use 1/500 second and a larger aperture. (It is worth remembering that no lens performs as well at its maximum aperture as it does a couple of stops or so down. Try some test shots, under ideal conditions, at the maximum aperture and compare them with others at, say, $f8$.)

Having stopped camera movement you must now do the same with the subject. Very often the setting necessary for camera movement will also be adequate for the subject, sometimes more so. In this event no further problem exists and you can concentrate on focusing. At one extreme some very slow speeds are possible—with basking seals and a camera on a firm tripod speeds possibly as low as 1/60 second. At the other extreme 1/1000 second will hardly 'freeze' a grouse in flight (see plate 17). Certainly it will not stop a really fast flying bird, passing closely and at right angles. A factor to consider is that you may not want to completely stop all movement on the subject. At the moment we are considering just the technical side of wildlife photography but this is not just a scientific hobby— it is a form of art, of portraying wild things in all their moods, and movement is a very basic and essential part of the beauty of our subjects. If you are to be successful you must at times express movement and this can be done in two ways. One is to 'freeze' the subject in such an attitude that it portrays movement, and the other is to permit part of the photograph to be blurred, thereby again expressing movement. This 'movement by blurring' can be achieved in two ways. One is to set a relatively slow shutter speed, say 1/250 second, and swing the camera with the subject which should remain sharp while the background is blurred. The other is to select a shutter speed which will keep the body of the subject sharp but permit the wings or legs to blur. In practice you rarely have sufficient knowledge of what is going to happen that you are able to pre-set with a specific effect in mind, but if you are aware of these techniques you can take advantage of them when the chance arises.

The problems of shutter speed are not so difficult to solve as they may appear. For stationary subjects you select a speed to eliminate camera shake and forget subject movement. For moving subjects you select a speed to eliminate subject movement and forget camera

shake. For any movement faster than a modest walk or a hovering bird you will need 1/500 second, so the choice really lies between 1/500 and 1/1000 second. A major consideration in choice should be not only the speed at which the subject is travelling but also the direction. For example, a grouse heading straight for the camera at 145 km.p.h. (90 m.p.h.) is not moving at all in the lens but simply growing slowly larger. Conversely, a hare crossing at right angles at only 32 km.p.h. (20 m.p.h.) at 14 m. (15 yards) is moving very rapidly (see plate 18).

It is impossible to give a set of rules on shutter speeds because every situation is different and also there is rarely time to consider them. In general terms the following should be helpful for moving subjects. Nothing under 1/250 second is likely to be any use. At this speed a gull hanging in the breeze or a rabbit loping quietly along should be captured. Modest movers, such as herons, crows, buzzards and badgers, should be given 1/500 second and ducks, hawks, game birds and other fast-movers 1/1000 second. But I would stress once more that the proximity and angle are more important than the actual speed.

A Summary

To recap: you can 'freeze' movement fairly easily by using a very fast shutter speed, but if you do the resultant wide aperture and narrow depth of field will give focusing problems. Experience and common sense will show how important it is to weigh every situation to use the best combination. For instance, on a really bright day you will be working at smaller apertures and can afford to select a higher speed. On a dull day it will pay to take risks with movement in return for closing up the aperture another stop or two.

One word of warning. Do not get so involved in the technicalities that you spend over-long thinking and not enough time pressing the button. Work out your values rapidly, take some shots, and with these safely on film check over your reasoning more carefully, re-adjust, and shoot again. But make sure of something.

7

Focusing

It is no exaggeration to state that success in wildlife photography, whether in still or cine, is impossible without the ability to focus rapidly and accurately on both stationary and moving subjects. From the previous chapters you will appreciate that the major focusing problem is the very small depth of field of telephoto lenses—there are others. Not the least is the fact that the subject is often moving, and even worse, you are usually unable to predict its movements. Normal photography frequently includes moving subjects but so often their path is predictable and focusing can be done in advance. Examples are racing cars, jumping horses, and organized sport. Additional hazards are that the natural camouflage of wildlife often enables it to merge with the background, thereby giving little to focus on, and, even when the subject is clearly in view time is often very short.

We are not helped by the mechanical methods of focusing usually available. The most common is the focusing ring, which is excellent on a light, standard lens where half a turn will usually cover from under a metre to infinity, but on a large telephoto the force required to turn it is greater and several turns are required for the same variation in range. The Hasselblad has, as an extra, an extension lever which gives much greater leverage and speeds up the procedure. The Rolleiflex SL66 has a knob on the body which extends the lens mount and bellows. It is a laborious process. Far and away the best is the trombone fitting for the Leicaflex. This has a quick release button which when pressed frees the two tubes and allows the focus to be taken from one extreme to the other in a fraction of a second. Releasing the button allows fine focusing to be carried out by a large, rubber ribbed wheel near the left thumb. I would use the system more than I do but for the fact that I need my colour photo-

7 The author (A.C.) and assistant lining up the frame of a hide to film woodpeckers before fitting the cover.

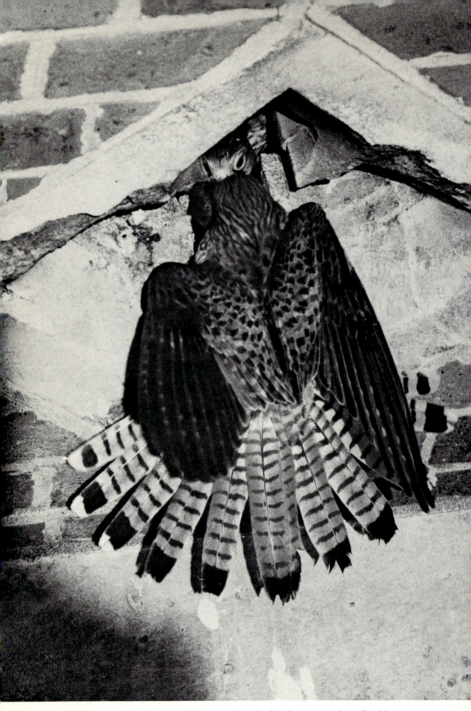

8 The female kestrel and the nesting site in the tower described in Chapter 2. Here the bird is passing a vole to one of the young. (See page 30)

graphs to be 2¼ in. square format. The hard fact is that all systems have some disadvantages and we must make the best of what we have.

The optical system for focusing varies from camera to camera, but the most common shows a small circle in the centre of the viewfinder which is more critical than the remainder of the frame and blurs even if the subject is slightly out of focus. This is an adequate system in reasonable light but decidedly tricky in dull conditions. If you will reflect back to my advice on lenses you will recall one of the advantages of the medium range was that they were available with coupled lenses which maintain the lens at its full aperture until the moment the shutter is released when the iris closes down to the pre-selected aperture. In some conditions you may be able to focus a large uncoupled lens at the aperture at which you intend to shoot and thereby save time, but where the subject is indistinct, or the light less than bright, you will have to waste a precious couple of seconds by focusing with the lens at its maximum aperture and then closing down to the correct aperture before exposing. This problem is insurmountable when the subject is moving for in the time you take to alter the aperture the creature will have moved out of focus. The solution is to close the lens to the smallest aperture at which the image is bright enough to focus and then alter the shutter speed to suit. The effect of this measure will often be to force upon you a very large aperture, with the poor depth of field this brings, but you will have no alternative.

You will save time and improve the accuracy of your focusing if, instead of attempting to focus upon the whole of the subject, you pick a part which is sharply defined and therefore lends itself more readily to determining, on the screen, whether it is in focus or not. A good example is a red deer which, when viewed as a dark brown beast against a background of dark brown heather, appears as a hairy blur. Ignore the body and focus on the antlers which are ideal for the job. Most subjects have sharp features of some description: examples are hares' ears, and the pronounced primary feathers of the wood pigeon. When you are near enough try to focus on the eye. It is usually bright and well defined, and if the eye is in focus the head must be (see the photograph of a hooded crow, plate 19). The head is critical—a slightly out-of-focus tail may be permissible but if the head is at all blurred the picture is a failure. If you have a chance of a good picture do not dwell over long on focusing or

you may find the viewfinder goes blank and yet another almost superb wildlife photograph is galloping away over the hills. Focus decisively and shoot. Then take another and this time by all means be ultra-careful over focus. I like to move the adjustment to and fro a few times each side of the point of focus to satisfy myself it is perfect.

If you find you have many out-of-focus shots check that the fault really is focusing. Some less expensive lenses really are incapable of giving a sharp photograph at their maximum aperture. Experiment in good light conditions with the camera rigidly mounted, a cable release, and a captive subject with clearly defined lines, for example a large poster. You may conclude that the lens should only be used at the maximum setting if there is absolutely no choice. Alternatively an unoffending lens has often been blamed for what is, in fact, camera shake. If part of the picture is in focus, even if it is not the part you wanted, and part out, then incorrect focusing is the culprit, but if no part of the picture is in focus then camera shake, or more correctly operator shake is more likely to be the cause. I mentioned earlier that the remedy, a firm tripod, is hardly practical for free-range photography. A great deal of help can be had by taking advantage of any rest that offers itself—a stone wall, a rock, a tree, anything in fact which projects above the ground and is firm. A companion's shoulder is better than nothing. One of the most valuable accessories a mobile wildlife photographer can have is a thumb stick. These are rarely seen in the south but are a common sight among the men of the north whose business takes them into the hills. Usually not less than 152 cm. (5 ft.) in length they are cut so that dividing branches leave a V at the top in which the thumb rests. For moving across rough ground they are a great asset, and the purchase given by the thumb leaves the hand less tired than with a conventional stick. But their real use begins with photography. With the point speared into the ground, the V forms a perfect rest for the telephoto lens and increases steadiness tenfold. You can either buy a fancy one with a V of horn, or go into a wood with a sharp knife.

Camera steadiness will be improved if you hold your breath just before pressing the shutter release.

Moving Subjects

The foregoing advice has been chiefly concerned with stationary subjects. The real difficulties begin when they are moving. You must expect that many shots at moving objects will be out of focus, and no matter how experienced you become you will never achieve anything like a 100 per cent. I am content if one shot in four at fast-moving subjects is sharp. All you can do is develop your techniques and seize your opportunities. It is better to risk wasting an exposure by acting rapidly than to lose a chance by pausing. Film is relatively cheap, and opportunities rare. With monochrome, blurred negatives can be detected in the darkroom before paper is wasted on them.

There are two basic techniques for focusing on moving objects: 'Follow and focus', and pre-set. Which you use depends upon the circumstances.

'Follow and Focus'

This method is only possible for subjects where the speed of movement is sufficiently slow for you to manipulate your focusing adjustment at a rate which will keep them sharp. Remember that speed, in the context of focusing, is concerned only with the speed with which the subject varies its distance from the camera. A wigeon downwind with a gale in its tail is no problem provided it is passing at right angles to the camera. Success depends upon knowing your equipment so well that you do the right things automatically. Speed of action is all important and the first need is to be able to pick up the subject in the viewfinder quickly. With a large telephoto this can be difficult, for the field of view is small. Having found the subject it is no good wildly moving the focus to and fro: you must know where your lens is focused in relation to the subject, for only then will you know which way to rotate the focusing ring or slide the 'trombone'. There is a good argument for keeping the lens focused at some average distance, say 18 m. (20 yds.), but personally I always keep mine at infinity. This is simply because I frequently cover rough ground with the risk of a fall and the whole unit is stronger when the lens and camera body are pulled firmly together.

Practice is vital, and there is no need to practice on wildlife. Vehicles are ideal. Begin by standing well back from the road so

that the variation in distance is small and the speed of change slow. Pick up the vehicle, or rather the part you are focusing on, at a good distance, so that you can watch it gradually blur as it nears, and then counteract. Then move nearer the road and delay the pick up, gradually setting yourself harder standards. Starting at infinity has the disadvantage that most wildlife opportunities will be moving away from you and both it and your own efforts are converging on the point of focus. As a result you pass through the point very rapidly. It would be better to start at point of near focus and chase the subject in the same direction. However, if you kept your permanent focus setting at the closest point the same problem would apply for approaching subjects. With going away subjects, and an infinity starting point, it is best to bring the focus in to meet the departing subject until shortly before the image sharpens and then to leave the focus static and wait for the subject to move into focus. This method prolongs the time the subject is sharp but obviously needs experience both in the technique and with the equipment. Here again the medium-strength lenses score for they enter their infinity setting at relatively near distances. My 250 mm. Zeiss reaches infinity at 137 m. (150 yds.) and at that stage I can forget focusing and concentrate on other problems. But my 500 mm. lenses still require focusing at over 274 m. (300 yds.). Your prospects of focusing on a moving subject are much less with a large lens, although if you are successful the image on the negative will obviously be much bigger.

Pre-Set

As the name suggests this method consists of setting the distance beforehand, picking up the subject in the viewfinder, waiting until the image sharpens, and firing. It is easier than 'follow and focus' in that less skill is required, but, as success depends upon the subject doing what you hope it will do, more opportunities are missed. Your application of this technique will vary according to whether the subject will be taking a definite route or not. Examples of definite routes are fulmars sweeping across the face of a cliff following the same flight path, or birds returning to a nest where the approach is restricted; an excellent example would be a swallow entering and leaving an old barn through a broken window. In such cases you simply focus at leisure, pick up the subject in the view-

finder, let it sharpen, and shoot. You may well ask how to focus on empty sky in the case of the fulmar, but you either focus on anything the same distance away or estimate the distance and set it on the focusing scale. There are many applications of this technique. You may be stalking a party of deer up a hillside and notice they are making for a ravine cutting through a sheer rock face. If you focus on a prominent rock in the ravine and then stand up the deer will run, giving an excellent action shot as they pass your pre-focused marker. The traditional February hare-shoots, when large numbers of beaters and shooters thin out the excess hare population, give good opportunities for photographing running hares. Hares have their long-established routes, and if one slips through a gateway or a hole in the hedge others will probably follow. Here is an obvious opportunity for pre-set focusing.

With a little forward thinking the method can also be used even where you do not know the route the subject will take. Consider walking through countryside where you may expect to see a particular quarry. The one certain thing is that wildlife, when startled, will fly or run away from you, and if you know the quarry you may expect to find, and the cover available to it, you can form a reasonable estimate of how near it will allow you to approach before it 'jumps'. For example, in moderately deep heather, grouse will allow you within 9–14m. (10–15 yds.), whereas in a field of short grass a covey of partridges will be away when you are no nearer than 91 m. (100 yds.). Having formed an estimate of how near you will be before the subject becomes visible you must assume it will cover another 14 m. (15 yards) or so before you can pick it up in the viewfinder and pre-set accordingly. An example of the pre-set method is the shot of two pheasants (see plate 22).

In concluding this chapter I will pay tribute to the work of my co-author, Anthony Clay, and his assistants at the R.S.P.B. In still photography we only have to get the subject in focus for a brief instant of time. In cine work accurate focus must be held for some seconds, occasionally longer. Next time you watch some of the magnificent sequences of birds in flight which are produced by the R.S.P.B. film unit consider the skill involved.

8

Light

I once stood on Westminster Bridge and watched a man on a bank of the Thames take handfuls of £5 notes out of a bag, throw them into a bath tub, and stir them about with a canoe paddle. I would have been very puzzled were it not for the presence of several cine cameras, big men in folding chairs, vans, a mobile canteen and all the other paraphernalia of a movie unit on location. However, the point that impressed me at the time, and is relevant to this chapter, was the battery of powerful lights which flooded the scene in spite of the fact that it was a bright day. Film makers, studio photographers, and many others are rarely bothered by light, for they work entirely, or partially, by artificial light over which they have complete control. The unfortunate wildlife photographer, once away from a hide, is almost entirely dependent on natural light, and all photographers will be aware how very important good light conditions are for decent results. It is no exaggeration to say that I would be more confident of good results using mediocre equipment in good light than top-quality equipment in bad. Of course photographs can be taken in any light conditions within the capabilities of the lens and film, but the results are sometimes so poor that the material would have been better saved.

The ideal light conditions favoured for most forms of photography are a bright day with just a thin haze of cloud to diffuse the sun. Direct sunlight is frowned on as being too harsh and producing results which are contrasty. Hazy conditions are also perfect for wildlife photographers, but I am equally fond of direct sunlight.

Many of our subjects are well camouflaged and it is difficult to make them stand out from their surroundings. As I explained earlier this can sometimes be done by deliberately using a large lens aperture and throwing the background out of focus. However, there

are many situations in which this is unworkable. Consider a rabbit on a sloping grass bank. The background is so close that only a very narrow depth of field will throw it out. In colour the brown rabbit will stand out well against the green grass but in monochrome the two colours will not have greatly different tones and a dull, lifeless, print will result. This is where direct sunlight will help by bringing out the texture of the fur by the strong contrasts between the highlights and the shadows. The shadow thrown by the rabbit on the ground will also help to create a feeling of depth.

This useful effect of sunlight can be seen on many occasions and with many species of wildlife. Look at the photograph of the hen pheasant (plate 23) and notice how the rather drab feathering has been brought to life by the highlights and shadows. A further advantage of strong sun is that it reduces the lens aperture with the consequent advantages already detailed.

The ideal position for the sun is behind and slightly to one side of the camera: the latter to throw the shadow texture into feather or fur. Of course we can very rarely determine the position of light and subject, but if you know the ideal you can apply this when building a hide or planning the line of a stalk. But whatever the angle of the light always take every opportunity offered. Many shots taken against the light are wasted but light plays strange tricks and the occasional photograph will be outstanding. Against the light shots are rarely good when considered as accurate photographic reproductions of the subject, but if we think in terms of taking pictures—of art rather than science—then you should take every chance offered. Such shots can be particularly effective when water is involved.

Snow or hoar frost conditions create exceptionally good light conditions. This is because the bulk of light is normally one-directional; that is it emanates from the sun, and while some is reflected from the ground this is not sufficient to avoid an unbalance between the light striking the side of the subject facing the sun (cloud covered or not) and the reflected light reaching the shaded side and the underneath. As a result if we expose for the brighter side we lose detail in the shadows and if we expose for the shadows we 'burn out' the highlights. But with snow or heavy hoar frost the reflected light increases dramatically and a far better balance is achieved. However, in these conditions you must expose specifically

for the subject or it will be grossly underexposed. Under normal conditions you must pay some regard to the background exposure but with snow it can be ignored; white is white and no matter how much you increase the exposure for the subject it will remain so.

Artificial Light

Artificial light is essential for photographing nocturnal animals: badgers, foxes and owls, for example, and also for some shots which are permanently in deep shadow—usually nests. An additional use is to 'fill in' part of a photograph to cure an over-contrasty situation. The use of artificial light is essentially restricted to situations which can be predicted and set up in advance; it has no application in free-range photography. It is not always used in conjunction with a hide; an example would be from a tree seat over a badger's set; but it is virtually always used from a static situation. As the intensity of light varies with the square of the distance from the source it follows that the power of the light falls off rapidly, and the result is that the background is either poorly lit or even appears on the photograph as a black expanse. Personally I do not like using artificial light but there are situations in which there is no alternative. There are two basic forms.

Flashbulbs
The initial equipment is cheap and light. They have a duration of 1/40 second or a little faster and are adequate for most situations in which the subject is only moving slowly.

Electronic Flash
Nearly all modern cameras have a synchronized shutter which is designed to fire an electronic flash when the shutter is open. This is the X setting; the M being used for the slower flashbulbs. An electronic unit costs from £8 upwards, but once acquired recharges from the mains, and when fully charged will give many more flashes than you can hope to expend in a day. Even the cheaper low-speed units will give flash durations in the region of 1/500 to 1/1000 second and are therefore perfect for arresting movement. Make a point of studying the instructions of flash relating to your own camera before both buying and using a flash unit.

Having acquired the equipment and finally arranged yourself in a hide before the home of your quarry you will, unless you have more foresight than most, be appalled to discover just how little you can see and how difficult it is to work by feel. Take heart—there is a solution. Virtually all wildlife ignores dull red light. This fact has two applications. Firstly if you cover a small torch with red paint, paper, or thin sheet plastic this will be excellent for working in the hide. Secondly, an enlargement of this device can illuminate the scene enough for you to know when to shoot.

The real lesson from this chapter should be that when light conditions are good get outdoors with your camera.

9

First steps

So far I have been concerned with theory but this chapter deals with the intensely practical business of actually securing photographs. Even for the man with some experience in both photography and the countryside success will be difficult; for the man who only has a knowledge of one branch, or neither, it will be well nigh impossible at the start—rather like attempting to drive a car in heavy traffic for the first time when there is just too much to do and think about at once. As with a car so, in time, much will become instinctive and you will have more time to think and act. An essential rule is to carry out in advance all acts that need not be delayed. The ideal is to be so organized that when the subject appears all you have to do is focus and press the button. In fact working from a hide focusing will already have been carried out.

Returning to the car analogy you will be sensible to start wildlife photography away from the equivalent of the busy roads. Pick a simple place and a simple subject and you will limit your faults and so make them more readily identifiable and curable. You are going to learn more with the first two rolls of film than the next ten so there is little point in spending time and money journeying to some distant spot in pursuit of some shy creature. It may not be an exciting start to your career as a distinguished wildlife photographer but an excellent place to begin is your garden. As an example (plate 13) this photograph was taken in my garden by my fourteen-year-old son. Every garden has birds, and the numbers will increase rapidly if they are suitably fed at a bird table. If the feeding point is arranged near a window of your home, or a garden shed, then there will be no need to build a hide. A little cunning, an essential ingredient for a wildlife photographer, will also make it possible to contrive results in which the table does not appear. A branch can

be arranged above the table, but just out of camera view, which birds will use as a landing and resting point when they come for food.

An alternative is to drill holes in the branch and stuff these with food. From your hide you will need just a hole for the camera lens, and a small peephole for one eye only. In fixed work of this nature it is tiring and pointless to look constantly through the viewfinder. Once the camera is mounted on a good tripod, and focused, you can use the peephole and shoot with a shutter-release cable when a subject is in the right spot. A set-up of this nature will allow you to practise both still and moving shots, for as the birds alight on, and depart from, the branch there will be an instant when they are both airborne and in focus. You will rapidly gain experience, not only in selecting shutter speeds and apertures, but in releasing the shutter at the right moment.

The next stage of gathering experience is to find wildlife which is accustomed to humans, and therefore prepared to allow a closer approach than normal. Strictly speaking this is cheating for you are not photographing true wildlife, but it is very difficult to know just where to draw the ethical line. Is a photograph of a red deer unacceptable because it was taken from a Land-Rover, or was that buzzard that allowed such an abnormally close approach ill? Certainly a photograph of a tame fox which was presented as a genuine wild animal would be unethical. My own view is that it is obviously wrong to pretend tame creatures are wild, but on the rare occasions when circumstances hand you an exceptional opportunity of a good photograph of a genuinely wild creature you are entitled to grasp it. However, leaving ethics and returning to practice, there is no question but that public parks provide some of the best possible training grounds. Most of our common birds, and many animals, are not only present but so accustomed to people that taking static shots becomes almost simple. These stationary photographs will give much experience and satisfaction, but once you have mastered the technique you must move on to the much more difficult moving shots. The most likely subjects will be birds, and your powers of observation will be required in noting their behaviour patterns so that you can anticipate their movements in advance. Sometimes this is easy; an example would be hard weather conditions with a small area of open water in an otherwise frozen

lake, and to this a constant to and fro traffic of wildfowl. This would present a splendid opportunity for action photographs by the pre-set focus technique. Your thinking might be on these lines, 'Although all the duck will come to the water-hole it is several metres across and therefore I will need the best possible depth of field. As they are landing their speed will be low and a 1/500 second may well be sufficient, which will give me a smaller aperture than if I use a 1/1000 second.' But having taken a number on a 1/500 second the prudent man will then do some repeats at 1/1000 on the philosophy that film is fairly cheap but frozen lakes are very seasonal.

Not all chances of moving shots are so straightforward. Still in public parks you might find an area of rough grass with wood-pigeons visiting it for clover. Here the potential landing area might be much larger, and the problems of focusing far harder, but some thought could minimize the difficulty. If there was a breeze you would notice the birds would always land into it, and standing to one side of the flight path would reduce the variety of angles and distances considerably.

The next stage is to photograph genuinely wild subjects in their natural surroundings, but you will rapidly discover the enormous variations of difficulty between, say, a golden eagle on a flat moor and a fulmar on a sea cliff. The former will not allow you nearer than perhaps three-quarters of a kilometre, while the fulmar seems to enjoy swooping past within a few metres. In fact the fulmar is an ideal subject, for it has a set flight pattern along the face of its cliff and is perfect for the pre-set focus technique. Try to avoid taking a sequence of similar shots, but constantly vary your position so that the bird is photographed not only from different angles but with different backgrounds.

This question of the number of shots you take of a particular subject and situation is important, for you must strike a balance between being 'trigger-happy' and being so careful that you miss chances. Your initial failing will be to waste film when the subject is just not large enough on the negative to give a decent photograph. After this experience you may swing to being over-careful, but when you do find a good opportunity take as many shots as you reason-ably can. If you have time take shots at several different apertures, angles, and distances, and then you can be reasonably confident that one at least will be good.

When you are approaching a creature it is good sense to take a shot as soon as you are within sensible range, and to take further shots as you draw nearer. This way you will have something, whereas if you aim for one perfect picture it may go in a flash and you will have nothing. The tawny owl (plate 24) was spotted dozing by the side of a track on Skye. From the time that I started the stalk to the time it opened its second eye and flew off I took five shots.

It is dangerous to dwell too long for any reason before pressing the button. You may be concerned about whether the cluster of wild flowers in the rock ledge in front of the buzzard is in focus or not. By all means consult the depth of field scale to find out, but before doing so make an exposure. Your rule should be to get a shot quickly and then to repeat it after re-assessing the various settings. When the chance is a rare one, and you have time, it is even sensible to get shots on two spools of film and to process them separately.

A Basic Summary

The basic techniques I have laid down so far may be summarized in two rules:

1. Spot or create the opportunity.
2. Pre-set the camera as far as possible, so that you are free to concentrate on catching the best moment.

I will leave the complexities of spotting or creating opportunities until the next chapter, but will deal now with pre-setting the camera. In free-range photography an opportunity may come and go in, literally, a few seconds and a rigorously maintained rule of keeping the camera pre-set at all times will often permit a shot which would otherwise be lost. When you know what to expect, and where, pre-setting can be entirely complete, but very often you will be exploring on chance and the settings will be determined by common sense. There are, after all, only three variables—shutter speed, aperture and focus. Focus we have already covered, and my advice was to always maintain the setting in the same position—preferably infinity when moving across open country. For free-range work you must assume the camera will be hand-held, or at least rested on a thumb stick. This means a shutter speed of not less than 1/500 second, and

as this will arrest most movement it is best to settle for this and enjoy the better depth of field you will have when compared to a pre-setting of 1/1000 second. With the shutter set at 1/500 second all that remains is to set the necessary aperture. This is difficult when you have no sure knowledge of the subject. The best compromise is to take a reading on a coat, rock, or any subject which has a fairly dull surface approximating in colour to the species of bird or animal you think is most likely to be seen. If in doubt increase by a half to one stop—it is better to be slightly over- rather than under-exposed. It is most important to watch for variations in the light conditions and to vary the aperture to suit. On a day of alternating bright and dull periods this can be a bore, but it is essential. Unless you are concerned over dust from extra dry conditions, or spray from rough water, keep the lens cap off. Get into the habit of re-cocking the shutter immediately you have made an exposure.

Finally, some minor precautions which can save trouble. Always check you have everything you need before leaving, and when you are making a long journey, or will be away for some time, include every item of equipment you have. If you do not you will surely need it. The best way of not forgetting the lens hood or some other item is to assemble the equipment for action before you leave. An alternative is to glue a check list inside the lid of the carrying case. Take plenty of film and also on your expeditions carry both monochrome and colour even though you have no intention of using both. Once used 35 mm. cassettes should be scratched, or marked in some way, to avoid putting them through the camera a second time.

Advanced work

In the previous chapters I have covered the specialized equipment and techniques associated with wildlife photography and now, like a driving instructor whose pupil has just passed the test, I stand aside for you to go forward to more difficult challenges. Whether you will retain a general interest in all aspects of the hobby or become a specialist in some department will depend upon you and your opportunities. At the beginning you will find results are more easily obtained from a hide, but this technique has been so popular for so long that there is very little that you can do that has not been done before, and probably better. The more exciting future belongs to free-range photography which offers a wealth of new situations and presents greater challenges. Success in free-range photography depends upon initiative, enterprise and, very frequently, rapid thinking and action. You may take days to produce a single good photograph but, unlike hide photography, it is not likely to be repeated by anyone else.

Creating Chances

I left for this chapter the explanation of the first of my two rules for wildlife photography—spot or create the opportunity. 'The opportunity' in the language of the wildlife photographer is a chance to approach sufficiently close to the subject to secure a decent photograph. This may seem an involved statement of a simple situation but if you persevere with the hobby you will, over the years ahead, reflect many times on how this is the crux of it. Success depends not only on an alertness of the eye and mind which will observe and act upon chances which others will miss, but upon tenacity. Let me give some examples. The photography of ptarmigan requires tenacity,

for this strange and exciting near relative of the grouse is rarely found beneath 600 m. (2000 ft.) and is well camouflaged for its life among the rocks of the higher Scottish hills. Success depends upon being tenacious enough to find the right areas, climb to the right height and then spend the necessary time, perhaps days, to find a few specimens. Unfortunately when you do the wind and weather conditions encountered in their natural habitat are rarely ideal for photography.

The need for an alert eye is obvious. One of my best red deer photographs resulted from my youngest daughter spotting, at a range of several hundred metres, the tip of an antler projecting above a rock. A careful stalk from downwind with the camera preset produced a shot for which I had been trying unsuccessfully for years. 'Creating' the opportunity can refer to an action, baiting by a hide for instance, which creates an opportunity from nothing, but you can also create a photograph from an existing but less exciting opportunity. The most common instance is by focusing on a stationary subject and then making it move before taking the shot. A simple example would be a grouse which you might spot as you drove slowly along. If you stop quietly, and without staring straight at the bird, it will probably shrink into the heather. Mark the spot very carefully, walk slowly and quietly to within, say 9 m. (30 ft.), set the camera (using a 1/1000 second) and then have an assistant walk towards the bird, but from one side to avoid obstructing the lens. If you have no assistant stamp your foot or toss a pebble at the spot. This procedure can be followed whenever the quarry thinks it is unobserved and prefers to hide rather than flee.

Many chances will occur where town or villages and the country meet and the wildlife is accustomed to people who do not harm them. The crow, for instance, is a most suspicious and wary bird, but the well-fed specimens that behave as if they own Epsom Downs will feed less than a metre from parked cars.

I mentioned earlier an alertness of mind, and this will help you to anticipate opportunities by weighing the circumstances. For example, severe weather may force wigeon to leave the safe expanses of the sea and fly inland to feed by day, or it can drive the snipe to any small patch of water still open when their normal feeding grounds are frozen. Such initiative can give exceptional chances but never forget the rule that the welfare of wildlife must come before

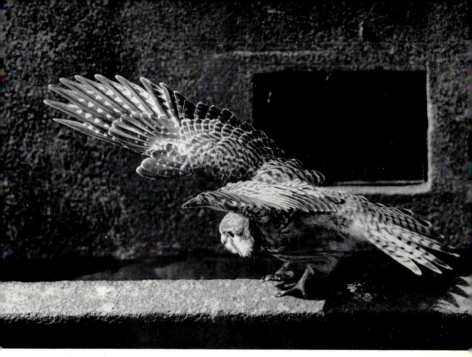

9 One of the young kestrels trying its wings on the roof of the tower. It was very noticeable how much less sensitive the young kestrels were to noise and movement than the adults. (See page 30)

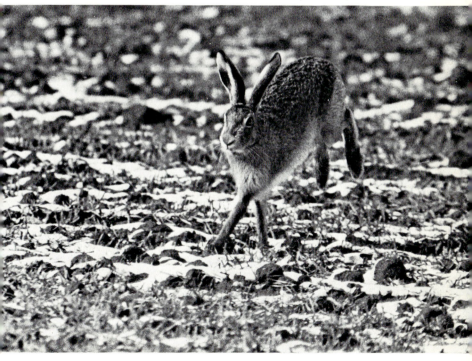

10 This effective action shot of a hare was obtained by taking advantage of the movements of the beaters at a hare shoot. To obtain such a photograph unaided would be almost impossible. (See page 32)

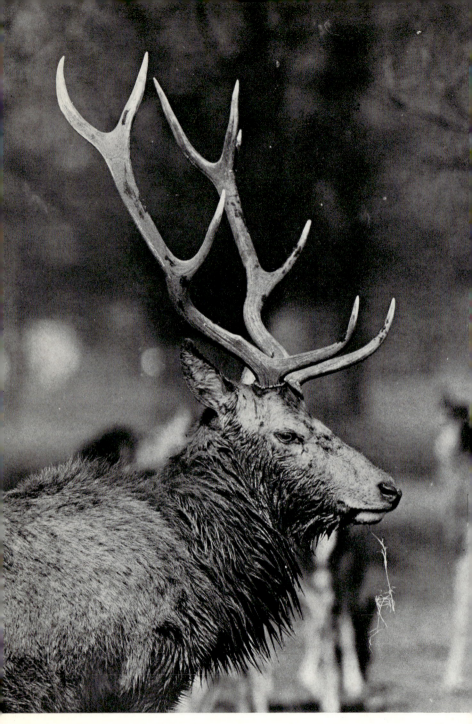

11 This red deer stag has been wallowing in a mud bath. To obtain photographs of deer and similar inhabitants of open countryside where cover is sparse often calls for a long and careful stalk. (See page 32)

our own ambitions—no photograph is justified if in securing it you brought suffering or possibly even death, to the subject.

Where to Seek

One of the first essentials of finding opportunities is to seek them in the right place. Most of us are tied by our work to a given area and we have to concentrate upon those species that are present, but it is surprising how much wildlife exists around us without our knowledge. I live in Surrey, and few of my neighbours realize that we have a very large population of roe deer. But, exciting though it may be to discover and photograph one's local wildlife, part of the fun of the hobby is to make expeditions either in pursuit of specific quarries or to explore new areas. In the early stages you will probably, and wisely, prefer areas where wildlife is plentiful, but a factor you must consider is trespass. Many townsmen fail to appreciate that not only are they not legally entitled to wander where they will over the countryside but that this is a restriction which many landowners enforce. Nor are the owners being unreasonable in this, for experience has shown them how much harm trespassers can cause. This can range from the simple unsightliness of litter to a major accident from an open gate allowing stock to wander on a road. In the wild hill country you can usually wander at will without anyone objecting, but in cultivated areas you should always seek permission. My experience is that the very act of seeking consent shows that you are responsible, and I am almost invariably allowed to go where I want.

However, I have wandered slightly from the subject of expeditions. As I wrote a little earlier you can either aim for a species or an area. An example of the former would be a visit to the Wash in mid-winter to photograph the pink-foot geese which winter there, and such a trip would be all the more satisfying if you returned with shots which captured the eerie loneliness of this vast, flat, grey, area, and also of the local people. Personally I prefer to explore an area rather than pursue a particular quarry, and my own area of special interest is the Hebrides. This is especially rewarding, in scenery and people, as well as wildlife. But they are rather distant, and there are many other parts of Britain which give a wealth of opportunities without the burden of a long journey. Membership of the R.S.P.B. will bring their magazine *Birds* regularly, and from

this you will glean many suggestions—their reserves are excellent hunting grounds for the photographer. John Gooders's book *Where to Watch Birds* published by André Deutsch is a good source, as also is *The Shell Nature Lover's Atlas* written by James Fisher and published by Ebury Press and Michael Joseph.

As public interest in wildlife and the countryside grows more and more is published on the subject. Reading through this literature you will often pick up snippets of information on the whereabouts of wildlife, and it is useful to keep a small indexed record of these for future reference. A tremendous mine of information for anyone interested in Scottish wildlife is *The Highlands and Islands* written by Fraser Darling and Morton Boyd and published by Collins.

Before visiting new ground it is wise to purchase the 1:50,000 (1 in.) Ordnance Survey maps of the area. A preliminary study of these will show the potentially rewarding spots and save much wasted time. But the real source of information is always the knowledgeable local people. I write 'knowledgeable' as the abysmal ignorance of some country people on wildlife in general, and their own in particular, is incredible. But if you go to the 'keepers, stalkers, shepherds, farmers and similar folk you will soon track down the right man or men. They are usually delighted to find someone who shares their love of wildlife and will usually tell you more in an hour than you could find out for yourself in a month. An invariable practice of mine, which I suggest you might adopt, is to send them a selection of the photographs you have taken. Some of these kind folk will be country people of limited means, but if you tip them you could cause offence. If they have children a shot or two of the family will give them immense pleasure, and if not one of the dog or their home will be welcome.

Touching on Art

Photography is very much an art, but in this section of the book I have been mainly concerned with technicalities. This does not mean that there is no art in wildlife photography; that it is simply a means of recording wild creatures; or that I am indifferent to the artistic element of the hobby. The explanation is that there is very little that the wildlife photographer can do to create art. It already exists in the shape, colour and movement of the subjects, and all we can

do is to capture it as best we can. There are a few occasions when one can make a constructive action; for example closing the aperture to bring some wild flowers in front of a dozing rabbit into focus, but, in general, events happen so quickly that there is little chance for composition. In so far as you have any control you should try to capture atmosphere, posture and movement. Do not ignore the small things of the countryside. A minor item of equipment will allow close-up photography, and some striking shots can be had of insects and small mammals.

Practical Tips

Experience will teach you many small rules not all directly concerned with actually taking the photographs but equally important to the success of the day. Some of these relate to the transport of equipment, for photographic equipment is fragile. Never place equipment on the seat of a car, for if you have to brake violently it will shoot on to the floor: it is wiser to put it on the floor at the start, and preferably on your outdoor clothing or some similar soft base. The method I described in Chapter 4 of padding equipment in plastic foam, enclosed in stout cases, is ideal for the rough-and-tumble of journeys and allows you to pile other luggage on top without damage. I have recommended that you should always have your equipment ready for action from the moment you set foot in the countryside, but there are exceptions to this rule. One is where you have a long walk over rough ground when the assembled equipment would be cumbersome to carry and liable to damage if you fell. Scrambling over rock-strewn ground in search of deer is a good example. In these circumstances it is best to wrap the individual items in generous layers of thin foam sheet secured with stout elastic bands; the whole then being carefully packed in a rucksack. In wet weather, and particularly when going on to salt-water marshes below the high-tide mark, individual items should each be placed in a plastic bag and the neck doubled over and tightly closed with elastic bands. Your film, both before and after exposing, should also be kept in plastic bags.

I would repeat the need to make a careful check that you have all the equipment you need before leaving home: good chances are rare and fate sends them more frequently when you have forgotten

a vital item. If you are going on a long expedition take every piece of equipment you have even though you do not expect to need it. On journeys to isolated parts take plenty of spare film stock. Rural stores are unlikely to have what you need, and if they do it is probably old or has been stored over the stove. Do not leave film stock in a car on a hot day.

With these tips I complete the section of the book that is my responsibility and pass you on to my friend Anthony Clay. I would end by stressing once more the absolute necessity of putting the interests of wildlife foremost. No photograph justifies endangering the life of the subject or its young.

Section Three

MOVIE PHOTOGRAPHY

by Anthony Clay A.R.P.S

11

Still versus movie

The liveliness that springs from movement gives live film a head and shoulders start over stills. A *good* film can be totally absorbing—I like to think far above the level of a slide show, however good it may be. In no field does this apply more than in wildlife photography.

Unfortunately many potential film-makers are put off by the belief that filming is more expensive, more difficult and far more time-consuming than taking stills. None of these facts is true in every case and there are many quite unwarranted fears.

It is true that it is usually more expensive to produce say thirty minutes of entertainment by film than by slides. But it need not be much more costly if you are careful, and once the technicalities have been mastered—and you have to master most of them before taking stills successfully—the important thing is 'planning', often called 'direction' which, while it is not easy, is great fun.

Although (as we have said in Chapter 2) the cine man does need a much higher degree of camera steadiness he need not necessarily be much less mobile than the still photographer. It is not difficult to hold the equipment steady. It simply takes a bit more time.

The work after shooting—the editing and so on—should not put anyone off. It is just as satisfying creatively as darkroom work with stills and with planning and practice can be cut down to nothing more frightening than a simple job of assembly. If, while you are shooting the film, you remember what will be your problems as editor you will have nothing to fear.

There is a popular misconception that no one ever took good stills *and* made good films. This simply is not true, though there is a good argument for not trying to do both at once. Apart from the physical difficulties of managing two cameras at once (try them!) it

85

is hard to concentrate on the two separate sets of problems at the same time. You will find that you can quickly lose planning control over a film if you do not give it your complete attention.

I have heard it said 'I'm not going to take up cine because it needs sound—and my hobby is photography.' Leaving aside the argument that a good slide show needs sound too, if you really do not want to tackle the interesting work of sound then it should not be difficult to find a friend who will—either an expert or a fellow novice, and many really good films have been made with no more sound track than a good commentary. Indeed even a soundless film can be very satisfying.

Film-making may be more time-consuming than still photography but if it is fun and it is your hobby this surely is not necessarily a disadvantage.

There are, however, two points about cine which present disadvantages when compared to still. Firstly, the film-maker cannot usually alter his shutter speed without altering the speed of action on the screen (this will be explained in the next chapter). So he has less control over what he can do to keep his exposures right. Secondly, the quality of his pictures will never be as good as stills which are exposed on a much larger format. Neither of these two problems are really very serious.

In virtually all other respects when photographing wildlife by still and cine the problems and satisfactions, difficulties and enjoyments are very similar and the advice and comments of Chapters 1, 2 and 3 apply to them equally.

Patience

I would like to conclude this chapter with a line or two on the subject of patience. 'You must have all the patience in the world to make wildlife films' people tell me. It is rather flattering and perhaps one of the secret satisfactions of the game, but it is not true. You do need perseverance, an ability to stand uncomfortable if not hard weather conditions, a good knowledge of the subject you are filming and (an ideal but not an essential) a sympathetic wife or husband. But patience—not really. If you seriously find you are having to grit your teeth and battle with boredom then you are probably in the wrong place or there at the wrong time. You would do far

better to make a fresh start elsewhere than to display 'all the patience in the world'.

After all, if you are not enjoying your hobby there is little point in practising it.

12

The basic technicalities

Even if you knew nothing of photography before starting this book you will now have a grasp of the basic principles. To re-cap, for a moment: light, in a controlled amount, is transmitted through a lens to the film which holds a chemical (called the emulsion) which undergoes a chemical change when struck by the light rays. This changed chemical is processed and the effect of the light rays is revealed in the form of an image.

There is little difference between still and cine in this principle, except that the process of exposure in the cine camera is a continuous one—that is a series of still photographs, each following rapidly upon another (at least 16 to the second). Each of these individual pictures is called a 'frame'.

To achieve movement cine projectors and cameras are alike in their transport mechanisms. The film is carried by a series of sprocketed wheels which connect with sprocket holes at the edge of the film. To allow a momentary pause so that the picture does not appear as a mere blur as the frames flash by, a claw engages in the sprocket hole as each frame approaches the 'gate' (or aperture) through which it is filmed or projected. When this claw has carried each frame into the gate it pauses and holds it steady before taking it forward, releasing it and returning to pick up the next one. During this brief moment, when each frame is being moved on into the filming or projection position, a shutter falls between the light source and the film so the screen becomes black for a split second. The human eye is not capable of recording this moment and only a slight flicker is noticeable. The individual pictures become merged and so a series of stills, in each of which the subject has moved slightly, give the appearance of movement.

Running Speed

In order to project the movement at a natural pace the running speed of the projector on which it is shown must be the same as the speed of the camera with which it was filmed. If the camera speed had been faster than the projector speed selected the action on the screen would be slowed down. Conversely with a slower camera running speed the action would be speeded up. So normally a standard speed is set for both. For silent films this speed is 16 frames per second. For sound it is 24 frames per second for professional use (25 frames per second for television) and 18 frames per second for amateurs.

Obviously with a fixed running speed the amount of light which reaches the film on each exposure cannot be controlled by varying the shutter speed, so normally the only control over the exposure of the film is through the lens aperture. In a few 16 mm. cine cameras it is possible to alter the angle of the shutter but this facility is designed either for special effects or for stopping the blurring effects of movement in very high speed cameras—only very exceptionally to control exposure.

The Sound Track

The sound track, if any, is generally transferred on to the edge of the film itself, to be replayed through a magnetic sound head or by a photo-electric cell. Alternatively it may be played back from a tape recorder synchronized to the projector. If it is in the form of a track on the side of the film the projector must run at a constant speed of 18 frames per second or more or the track will not pass through the sound system fast enough to give good quality reproduction.

Film Gauges

The quality of the projected picture depends largely upon the size of the film on which it was recorded. The commercial cinema uses the 35 mm. format (the same size as most amateur still cameras) or larger. Television cameramen and most professional documentary film-makers generally use the 16 mm. format. All but the most serious amateurs use standard 8 mm. or the majority, nowadays,

super 8 mm. Super 8 mm. is really only a better way of using all the emulsion area available on 8 mm. film and is rapidly superseding standard 8 mm. just as 8 mm. superseded 16 mm. as the main amateur gauge. The old 9·5 mm. gauge with its 'down the middle' sprocket holes is now almost obsolete.

13

Movie equipment

The equipment you will need to begin filming wildlife must have certain basic features. It must be possible to use the camera on a tripod and there should be a facility for changing lenses. It is also important for there to be a reflex, through-the-lens viewfinder (so that the cameraman sees exactly what the lens sees), an electric motor, and a zoom lens. A well-fitted carrying case, which holds the camera and one lens set up for seizing a filming opportunity if one arises, is very useful. You will also need to be able either to fit a telephoto lens directly on to the camera, or a supplementary lens on to the standard built-on lens.

Clockwork versus Electric Drive

The power used to transport the film through the camera is now generally electrical (from a small battery) but there are still a few clockwork-driven cameras on the market. The main and obvious disadvantage of the clockwork motor is that it rarely runs for more than about 19 seconds and this is frequently far too short a time for your animal or bird to complete some fascinating action. For wildlife photography I definitely recommend an electric camera drive.

8 mm. versus 16 mm.

Before purchasing a camera it is only sensible to decide on the extent of your ambitions. If, like most people, you only want to make films for your own amusement, and to show to your family and friends, then an 8 mm. set-up will be adequate. But if you are seriously thinking of showing your films to audiences of more than, say, twenty-five people, or even hoping to reach television, or a similar

wide use, then you must consider buying 16 mm. which is the smallest possible professional gauge. The other main advantages of 16 mm. over 8 mm. or super 8 mm. are better quality of picture and sound, better laboratory facilities, wider choice of films and the ability of the cameras to take a wide choice of lenses. The main disadvantage of 16 mm. over 8 mm. is cost. It is at least twice as expensive, both in equipment and in film. So let us assume you will be starting with 8 mm. All further information in this chapter refers to 8 mm. To find the equivalent in 16 mm. multiply by two and you will not be far out.

Standard 8 mm. versus Super 8 mm.

The problem of whether to purchase standard 8 mm. or super 8 mm. is easily answered. Unless you are offered really good-value 'used' standard 8 mm. equipment buy super 8 mm. Super is a modern development which improves picture quality by using more of the available width of the film which remains the same size and costs very little more. This is achieved by reducing the size of the sprocket holes and other formerly wasted space. The two systems are not interchangeable, though it is possible to buy projectors which, with adjustments, will show both. One great advantage of super 8 mm. is that the film is supplied in easy-to-load cassettes which both save time in lacing the camera, and wastage of film from light leaks when changing reels under the alternative system. A possible disadvantage of the cassette load 'split gate' system is that the film does not lie quite as flat in the camera as with the standard gate system, so the picture can never be quite as consistently sharp and steady. But this is a very small point and modern cassette design seems to have taken care of most of the problems.

The lenses used are the same size for both and in every way the techniques are the same.

Lenses

There are now many good zoom lenses which, of course, in one unit give a range of magnifying powers. But none of them gives the degree of magnification that you need for real close-ups of small subjects. The standard lens for 8 mm. cine has a focal length of

12·5 mm. ($\frac{1}{2}$ in.). With this lens a mute swan, filmed at 244 cm. (8 ft.), will just fill the screen. But at the same distance a sparrow would not fill one-eighth of the screen. So to get a close-up of a small bird at this range (and it is usually very difficult to get closer) you must have at least eight times magnification. This requires a lens with a focal length of 100 mm. (4 in.) or more. The longest zoom lens available for 8 mm. cameras has a range of focal lengths of only 8 to 80 mm. So for work with many wildlife subjects you will need a lens with a focal length of not less than 100 mm., i.e. a telephoto lens. It follows that a camera on which the lenses can be changed is a great advantage but, unfortunately, modern cameras in the medium or cheap price range do not have this facility. Therefore, unless you have at least £450 to spend, you have a choice of:

1. Buying a used standard or super 8 mm. camera with this facility or
2. Adding a supplementary lens to the one supplied with the camera. Some binoculars can be used for this purpose by attaching one eyepiece to the front of the cine camera lens so as to film through half the binocular.
3. Concentrating on subjects which do not require large telephoto lenses.
 Consult your dealer, he should know the used as well as the new market and may well have the solution.

Viewfinders

Expensive cameras have 'reflex' or 'through-the-lens' viewfinders. With them you have the advantage of seeing exactly what is being recorded onto the film.

On cheaper cameras the viewfinder does not see through the lens but to one side or above it. This gives problems because the operator is not always seeing through the viewfinder exactly what the camera sees. So he must allow for this by remembering to aim the camera slightly above or to one side of the subject as seen through the viewfinder. The nearer the subject is to the camera and the larger the focal length of the lens, the greater is the correction required. It is called 'parallax'.

Tripods

A tripod or some alternative form of firm camera support is absolutely vital. In still photography you can usually adjust the camera shutter speed so that camera shake at the time of exposure will not show on the picture. At a very fast shutter speed, that is in excess of 1/250 second, the distance travelled by the lens on a shaky camera during the brief moment of the exposure is so small that the recorded image is hardly blurred at all. So that, with care, it is possible to use a hand-held still camera even with a 400 mm. lens (8 mm. cine equivalent of approx. 100 mm.). But with cine every camera movement will show as a jiggle on the screen, and the longer the focal length of the lens the greater the jiggle. Therefore in wildlife work, where so often telephoto lenses are used, it is essential to hold the camera very very steady.

Pistol Grips

Unfortunately many cine cameras are designed with the idea that all amateur cameramen need is a camera they can 'aim and shoot' with, and built-in pistol grips are now standard on most modern 8 mm. cameras. Although most of them have tripod screws in their bases this is not the best place to attach the tripod as the balance is wrong. A screw thread in the base of the camera body and as near the centre of gravity as possible is a great help.

Tripod Heads

Having eliminated uncontrolled movement we must now consider achieving controlled, but smooth, movement. Obviously a completely stationary position for the camera will only be of use when the subject does not move and as stationary wildlife subjects are normally boring most work will be done on moving subjects. This calls for a tripod head which will allow you to pan and tilt the camera smoothly. Most professionals use a tripod with fluid head. With these the movement of the head is controlled and smoothed by a bath of thick oil, through which vanes move when the camera is tilted or panned. They are very expensive and out of the reach of most amateurs. But a good firm rack and pinion, or large ball and

94

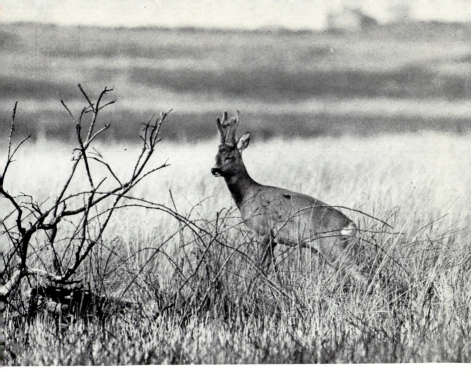

12 A roe deer with his antlers in velvet—an easy shot provided it is taken quickly before the animal flees. (See page 64)

13 This very young grey squirrel, photographed by a son of one of the authors, had escaped from its drey prematurely and provides a very rare example of an easy wildlife photograph. (See page 72)

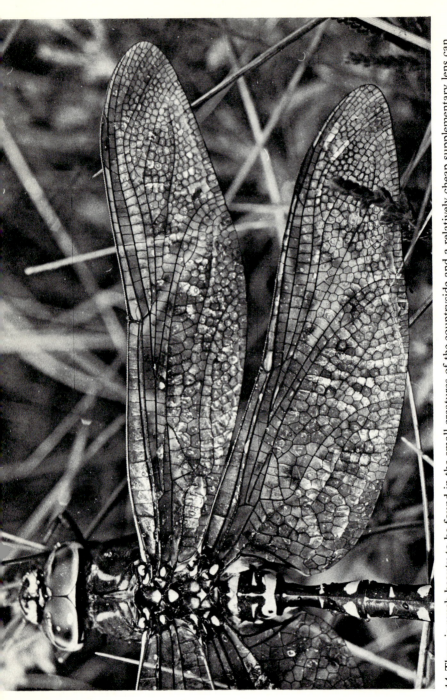

14 There is much beauty to be found in the small creatures of the countryside and a relatively cheap supplementary lens can capture this. The drops of rain show this dragon fly is drying out after a shower. (See page 43)

socket type of tripod head, is much cheaper, adequate, and essential.

Although tripods will hinder your mobility slightly, with practice you will find they do not get seriously in the way. Without one you will suffer unsteadiness on the screen which not only looks 'amateurish' but is downright distracting.

Filters

Many modern super 8 mm. cine cameras are now fitted with an ingenious automatic filtering arrangement. This is a built-in, daylight filter, which is automatically pushed out of the way when the lighting unit is attached to the camera. This simple arrangement means that normally only artificial light film stock need be used, but it has the snag that by filtering the lens the amount of light reaching the film is proportionately reduced. This requires the use of a larger aperture to achieve the correct exposure.

Apart from the correction filters for using artificial light film by daylight and vice versa you may well need others, as in still work. An ultra-violet or 'haze' filter is very useful for distant scenes or when filming from the air or on mountains. Yellow and red filters are, of course, useful if you are filming in black and white, though for wildlife work this medium is now rarely used. And there is a vast range of different filters to create special effects.

Filters are most easily accommodated between the back of the lens and the film, for they are then so near the gate that the size of filter needed is much smaller than elsewhere. There are two forms of filter; gelatine (cheapest and easiest to use) and optical glass (more expensive but giving rather better quality). Glass filters are usually screwed on to the front of the lens.

The Basic Outfit

The cheapest type of super 8 mm. camera that you will be able to buy new, and which has the basic requirements, will have the following features:

It will need at least a 10–40 mm. zoom lens and a screw thread for a tripod.

The viewing system will not be through-the-lens as with more

expensive cameras so you will have to remember to allow for the fact that you are not seeing precisely what the camera is seeing.

It will not have a provision for a very long telephoto lens.

It will only be capable of running at one speed, preventing the use of slow motion or speeded-up special effects.

Above all it will suffer from the disadvantage that, because of the limits of its lens power, there will be many good subjects, such as large close-ups of small birds, which it will not be able to tackle. It will cost about £80. I suggest the following models: Rollei SL 81; Sankyo Super CM400.

The Optimum Outfit

The most expensive type of 8 mm. camera will cost about £500. In addition to lens-changing facilities, a zoom lens, through-the-lens viewing and all the other useful facilities, it will have through-the-lens exposure metering. This means the correct exposure is set automatically—a very useful asset indeed in wildlife work. One outstanding example comes to mind—the Beaulieu 4008ZM MkII at approximately £450.

The Compromise Outfit

Between these two types there lies a large range. Generally speaking you will get what you pay for. Whichever you buy do ensure that there are really good, not merely adequate, servicing and repair services available. A cine camera is a mass of moving parts which can, and all too frequently do, break down.

I would recommend buying a well-tried model from one of the more firmly established manufacturers. Some recent new designs, which seem to have been rushed off the drawing board, give trouble because their interesting and sometimes gimmicky features do not stand up to use in the field. Examples of reliable models are: Yashica Super 800 Electro £180; Sankyo Super CM600 £125; Eumigette 8-40 £120; Canon Auto-Zoom 814 £200.

Film Stocks

This is the term used professionally to describe the photographic

material used in making films. Camera film stocks are the ones on to which the original picture is exposed.

Professionally they are too delicate to be projected without becoming scratched and are manufactured to give the best possible results when copied. Amateurs usually use camera stocks which are tough enough to be projected. They can be copied but will not give results of very good quality. Print film stocks are those on to which copies are made.

Some films are 'faster' than others. That is to say they need less light to be correctly exposed. The disadvantage of fast speed is in reduced definition, greater granularity (the snowy effect on the screen), greater contrast and less accurate colour reproduction. Sometimes though, it is necessary to use fast stocks because there is not enough light or when using high filming speeds which reduce the amount of light reaching the film. Speed is generally expressed in figures ASA (American Standard Association) or degrees DIN (the initials of the German Industrial Standard). The higher the number the faster the film, so if the ASA number is 50 (DIN 18°) you will need half as much light as for a film rated at ASA 25 (DIN 15°) i.e. you will have the advantage of one stop less exposure required.

In standard and super 8 mm. gauges there is really only one type of film which is suitable, a colour camera stock designed for projection. Kodachrome and Gevachrome are the most widely used stocks but there are several others e.g. Fujichrome, Anscochrome, Ferraniacolor and Perutzcolor. All are available in standard and super 8 mm.

Standard 8 mm. film comes on a spool of 762 cm. (25 ft.) long and approximately 16 mm. wide. This is run completely through the camera and half the width is exposed. It is then turned over and run through again so that the other half width is exposed. The processors split the film down the middle, join it together and return the 1,524 cm. × 8 mm. duly processed. Super 8 mm. comes in one cassette of 1,524 cm. length and 8 mm. width. The processors do not have to split it and it is simply processed, rewound and returned. Each reel or cassette runs for about 3 minutes at silent running speed, or for slightly shorter at sound speed.

Black and white films for 8 mm. are now very hard to obtain and certainly people would much prefer to see wildlife in colour.

Artificial and Daylight Film

There are basically two types of colour film, the artificial light and daylight types. This is because the 'colour temperature' of these different light sources varies, daylight is much colder (bluer) than artificial light. You can use film designed for artificial light in daylight, but you must use an amber filter on the lens. Equally you can use daylight film in artificial light with the aid of a blue filter. More on the use of artificial light in Chapter 14.

In 16 mm. there is a much wider choice of film. As well as the reversal stocks which are widely available in fast and standard speeds there are the negative stocks. The difference here is that, where reversal films record a positive image which shows the scene as it was, the negative film records the scene with dark and light areas and colours reversed. A positive print must be made from it for projection. It has advantages in greater latitude (it is more tolerant of slight inaccurate exposures) and in very accurate colour rendition. One disadvantage is that any dirt specks on the negative show up white on the positive and are therefore much more noticeable than on reversal stocks. Another is that since it is very difficult to judge results from the negative alone it is important to copy every single shot taken. Reversal stocks can be more easily pre-selected before printing. Negative stock is very widely used in television.

Sound on Film

There are available 8 mm. cine cameras with synchronized tape-recording facilities through a standard cassette type of sound recorder. The film and the tape cassette are eventually replayed through a projector which achieves synchronization of tape with film in the same way. Alternatively the camera may be capable of recording sound on to a magnetic stripe running down the side of the film. Frequently this is not very suitable for wildlife work because the standards of the recorder and the microphone are not high enough to make good quality recordings of most wildlife sounds. In any event it is hard enough to film wildlife alone without trying to sound record it at the same time. It is much more sensible to make your sound recordings separately and later synchronize them to the film.

Not unnaturally, the more expensive the tape recorder the greater the range of subjects you can record.

Wildlife Sound-Recording Equipment

It is not within the scope of this book to go into detail on wildlife sound recording and I recommend *Bird Song Recording* by Frederick Purves (a Focal Sound book), and *The Encyclopedia of Tape Recording No. 1—Natural History Sound Recording* by Richard Margoschis published by Print and Press Services Ltd., East Barnet, Herts., for this subject. Perhaps you will eventually derive the greatest satisfaction from working with a companion who concentrates on the sound recording side. But if you are a 'loner' and *must* do it yourself here is a very brief potted guide to the equipment needed. You will find more on the techniques of sound in Chapter 15 and how to add it to your films in Chapter 20.

There are several technical factors which control the quality of a sound recording. The speed at which the tape is running through the recorder (the faster the running speed the better the quality); the width of the recorded track (the wider the better); the quality of the amplifying equipment in the recorder and the quality of the microphone. Professionals use a tape running speed of not less than 191 mm. per second ($7\frac{1}{2}$ in. per second). The cheapest cassette recorder runs at 45 mm. per second ($1\frac{3}{4}$ in. per second); professional recorders generally use half the tape width for recording. Most inexpensive recorders use half or even a quarter of the tape width. A few very quality-conscious wildlife recordists use the full width.

The quality and strength of the amplifying equipment varies with the cost of the machine and a professional quality recorder will cost no less than £100. It is useless to buy an expensive microphone without a good machine to support it, for the quality of the recorded signal depends as much on the recorder as on the microphone. My advice is to use one of the better portable 'domestic' recorders with its own crystal microphone and to fix the microphone in a parabolic reflector to concentrate sounds. It works rather like a telephoto lens on a camera. You will find instructions on how to make one of these in *The Encyclopedia of Tape Recording No. 1*, mentioned earlier.

Wind often sounds like thunder on a recording, so keep the

microphone very well-sheltered even from breezes and, if necessary, wrap it in a foam rubber anti-wind pod.

Projectors

Any standard form of projector will suffice provided it is of a reasonable quality. The facilities available on different models, both 16 mm. and 8 mm., include zoom lenses (which allow you to project the right size of picture onto a given size of screen without moving the projector), quiet running sound facilities, extra bright light output and the capacity to take long running film lengths.

In 8 mm. the most expensive projector with all these features will cost about £150. The cheapest, more basic, projector of good quality will cost from £50. There are usually a few good used models on the market.

Used Equipment or New

As you will realize by now wildlife film-making requires rather specialized equipment. Manufacturers cannot provide such specialized cameras and lenses cheaply in view of the relatively small market which exists for them (most amateur cine cameras are made for simple domestic use, i.e. for filming the baby on the lawn or the family on holiday).

I do recommend, therefore, that if you are serious about wanting to tackle the more difficult subjects (e.g. filming small subjects from a distance) but reluctant to face up to the expense of a new camera you should contemplate buying a secondhand camera which has the adaptability so rarely found on most 'more modern' cameras. In particular the Bolex H8RX has most of the necessary features and is very sturdy and long-lasting.

Alternatively do not dismiss the idea of buying used, or even new 16 mm. equipment. Expensive new 8 mm. equipment is sometimes more expensive than used 16 mm. It is a reasonable argument that the high cost of 16 mm. film stock is often offset by the fact that the cameraman is much more careful not to waste film and so finishes up with results which are of better quality and also cost little more. Consult your dealer. He should be professional in knowing the equipment market and may even make wildlife films himself.

Remember that whatever you eventually buy it will always be the finished product that counts. Quality is important but ideas are far more important. A film which expresses an interesting idea and moves at a good pace, even if it is a bit 'fuzzy at the edges', will always beat a boring film, however high its quality.

If you cannot afford the more expensive equipment you will merely have to avoid those subjects which call for it and concentrate on those, and there are many (see Chapter 17), which *are* within your budget.

14

Filming techniques

The special wildlife filming techniques which will help you to get into a position to film your subjects, at a reasonable range, and without disturbing them, are almost identical to those used for still photographs. Hide work, filming from a car, stalking, baiting, are all basically the same whether you have a cine camera or a still camera.

There are two points, though, which may be very important when you are filming the shyer animals and birds.

Firstly, you will have to be very careful about lens movement. To make an interesting film you must be able to pan and tilt whenever you want to. Yet from the point of view of your subject such movement is often very disturbing.

Secondly, you will have to watch carefully the reaction of the subject to the noise of your camera. Some mammals and many birds seem surprisingly unworried by strange sounds provided they are not too sudden. So they react to noise, or the lack of it, more when the camera starts and stops than to its running sound. But a few species, owls for instance, have very finely developed hearing and for them something must be done to lessen the shock. A 'blimp' or sound-absorbing box around the camera can be an elaborate affair masking nearly all sound. You can make one yourself by lining a wooden box with plastic foam, but I find that to dampen the noise of an 8 mm. cine camera one only needs a sheepskin cover which can be zipped over it.

Alternatively, if you are using a hide, you can try another approach and get the subject used to the noise of the camera by running it, without film, for gradually increasing periods. Or you can play back a continuous tape recording of the sound. I once had such success with this method with a shy hen sparrow-hawk that eventually she

became so used to peculiar noises from the direction of my hide that I could even whistle a tune without her blinking an eyelid. Yet her instant reaction to the distant calls of her mate showed the she was far from deaf.

Having disposed of the two major difficulties let us now go through the basic techniques of filming. There are rather a lot of them but they are mostly based on common sense and they are worth following. I am afraid that if you do not pay attention to these main points you will be disappointed in the results. By all means break the rules if you want to, but do learn them first so that at least you will know *when* you are breaking them.

Loading the Camera

Many beginners make their first mistake with this initial act. Never load the camera in a bright light—always load it in the darkest place available or your films will suffer from the dreaded 'edge fog'. This shows itself in orange flashes, usually at regular intervals along the film, generally on one edge. It is simply caused by light leaking on to the film before processing. It sounds ridiculous but it is just about the commonest fault in amateur films and it even occasionally occurs with professionals. If Mr. Coleman made his millions from the mustard people left on the sides of their plates, a large part of Mr. Kodak's wealth must have come from stock replaced through the edge fog which people allowed on to the sides of their films. The modern, more light tight, super 8 mm. cassettes have eased the problem a bit but take care all the same.

Another useful tip in loading is to become familiar with the sound your camera makes when running with the film properly loaded. Then you should be able to tell by ear if there is something amiss through faulty mechanism or faulty loading.

Focus and Depth of Field

If you have a through-the-lens reflex camera focusing should not give you much trouble, for you see what the camera sees and then adjust the focus until it looks sharp. With non-reflex viewing your problems are enormously greater even if you have a good range-finding system (as discussed in Chapter 13). Range finders work by

103

showing you two images of the subject which overlap when the finder is adjusted to the correct focus. It really does mean that a non-reflex system will steer your filming away from the difficult, large close-ups of shy species and force you to look for new approaches to the reasonably un-shy subjects.

Much of the emphasis in the old days on studies of birds at the nest was due to the problem of adjusting focus on a moving subject. If we are trying to get away from that kind of stereotyped filming the first essential is a good focusing system.

Closely linked with focus is 'depth of field' and in this 8 mm. users have a great advantage over 16 mm. Every time the subject moves nearer or further it is necessary to adjust the focus of the lens so that it is kept within an area of the acceptable sharpness. The size of this area, i.e. the amount by which the distance between the camera and the subject can be varied without losing acceptable focus, is called the 'depth of field'. It varies with the size of the lens you use (the longer the focal length the smaller the depth of field), the distance of the subject from the camera (the nearer it is the smaller the depth of field) and the aperture of the lens you are using (the larger the aperture the smaller the depth of field).

Obviously the greater the depth of field the greater permissible margin of error exists with the focusing. This is one reason why it is a golden rule in photographing wildlife that if you need a larger image of the subject you should get as close as possible to permit the use of a less powerful telephoto lens.

A useful method of achieving accurate focusing without through-the-lens viewing is to set the focusing on the lens at a likely distance which you also set on a range finder attached to the camera. By pre-focusing the lens at this distance you can start filming the instant the two images merge on the range finder.

If you have through-the-lens reflex viewing and can tackle changes of focus as the subject approaches or moves away it is well worth practising before you start filming. By practising just how far and fast it is necessary to move the focusing ring as the subject moves you will soon become moderately accomplished at holding it in focus. To keep movement going on the screen without losing focus is one of the great arts of film camera work.

Exposure

Even with modern colour films, which fortunately have much higher latitude than the old, you must still be accurate with your exposures. Just as for stills the exposure is varied with a diaphram inside the lens which is opened or closed to allow more or less light through to the film. It is calibrated in stops, or 'f' numbers, which usually run as follows: 1·4, 2·8, 4·5, 6·3, 8, 11, 14, 16, 20 and 24.

It may seem rather an extraordinary series of numbers but each number represents twice as much light transmission as the previous number, and half the amount of the following number. So at a setting of f 11 the film will be receiving a quarter of the light which it gets at f 6·3.

You can estimate the exposure by using the guide which is supplied with the film but this is not an accurate process. It is usually on a 'dial the weather' principle with a setting for 'bright sunlight', 'cloudy bright', 'dull' and so on. It is far better, and in some conditions almost essential, to use an exposure meter (and if you turn back to Chapter 4 you will find detailed advice). Whether still or cine the same arguments apply for and against built-in exposure meters. In cine, remember, the shutter speed is controlled by the running speed of the camera, so to determine the correct exposure you have only to equate the speed of the film with the brightness of the subject.

As with still photography there are two types of exposure meter readings—incident and reflected light readings, i.e. aiming the meter at the light source to record the brightness of the illumination or aiming it at the subject and finding out how much light it is reflecting. Ideally you should take a reading by both methods, and then average out the two, but usually you will only have time to take reflected light readings. This is what a built-in exposure meter will do.

If you are filming from a hide and cannot put the meter outside without frightening the subject, take a reflected light reading before you set up in the hide and before the subject has returned. Then take an incident light reading from inside the hide. Light changes while you are filming can then be monitored by taking regular incident light readings inside the hide and altering the lens aperture accordingly.

When filming in colour you must try to be accurate to within at

least one stop either side of the correct setting. If you over-expose a film the colours will be pale and washed out; if you under-expose they will be dense and over-saturated. There is very little that can be done in copying to improve the situation for a copy can never be better than the original.

Composition

To me this aspect deserves a book in itself. If your film presents a sharp, well-focused and straightforward representation of events as they happened you will have good cause for satisfaction. But if you want to make a film that is exceptionally good to look at or which moves the audience to see your subject in a new light, then good composition is of paramount importance.

There is an important difference here between still and cine work. In still you can often crop the picture or enlarge only a selected part of it after you have taken it, that is you can, effectively, compose the picture 'in the darkroom'. In cine you have to compose it 'in camera'.

There are basic conventions about compositions which are well worth remembering, especially if you intend to break them:

1. A subject moving laterally across a scene should be positioned so that there is more space in front of it than behind it, otherwise it would give the uncomfortable impression of being about to collide with the edge of the picture, thus:

Fig. A Fig. B

2. The strongest parts of a picture are those intersected by lines drawn at one-third intervals horizontally and vertically across the picture, thus:

Fig. C

This rule is particularly important in scenics of flat country-side where it applies to the strong line formed by the horizon. If you place the horizon centrally the result will be less effective than if you place it on one of the two horizontal lines at one-third intervals up and down the picture, thus:

g. D Fig. E (See Fig. F. overleaf)

107

Fig. F

It must be remembered that a shot that does not 'look right' often niggles in the minds of the audience and detracts from their understanding or enjoyment, if only for a second or two. Consider, for instance, two drawings of a flag on a flagpole. Which looks right?

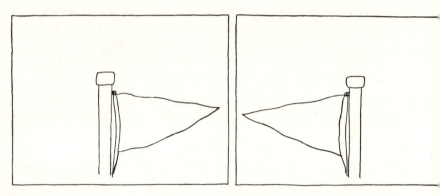

Fig. G Fig. H

Most people would say the one on the left is more comfortable to look at. In fact it would be better to line up the flagpole one-third from the left of the picture. This is the essence of composition. A good composition 'looks right' a bad composition is, to most people, 'awkward'. Most compositions fall between the two and are neither good nor bad but it is essential to try for the good!

Movement

One of the greatest skills which the cine cameraman possesses is to know when, and when not, to move his camera about. To film only with the camera locked solidly in one position will produce a film of 'moving stills'. To film with a succession of tilts, pans and zooms will send the audience out of the room with heads spinning and eye-balls popping. So try to intersperse your film with stillness and movement as the pace directs. Use stillness when you want to create a time for the audience to pause and study; use movement to quicken the pace and to carry the audience forward with the progression of the subject. Ideally the camera should not be *known* to have moved, it should so follow the subject that the subject itself gives the flow of the sequence.

To illustrate this take an example of a film on flight. Movement is the essence of this subject and yet too much camera movement will soon become frenetic and disturbing. But how can you follow a bird in flight without moving the camera? The answer is to select a sequence when a wide angle view can be taken, looking from a distance. A mass of distant birds in flight would give this effect, so build such a shot into your filming. The feeling of continuous flight will not be lost but the audience will have been rested from the sense of continuous movement.

It can be very useful to make a few 'whiz' pans. These are short pans at a fast speed. They can sometimes give a very effective way of linking shots in a fast moving sequence. But usually a pan must not be performed too fast or the scene becomes impossible to watch. Move the camera steadily and deliberately, especially when you are panning over a scenic view. It is rarely a good idea to pan for too long over a scenic shot. Because the width of the picture remains the same, the resulting long take gives more the effect of tedium than of expanse. Avoid panning over a scene with strong vertical areas of white in it, for example a white fence, or the white areas will 'strobe' producing a very distracting flicker.

Remember that film making techniques should not be obtrusive and the audience should follow the film by the logical flow of the sequence rather than by elaborate camera movements.

Tripod or Hand-Held

There is, unfortunately, a limit to the use in wildlife cine photography of the hand-held camera. Except for very fast-moving subjects you will never achieve a satisfactory steady shot hand-held with a telephoto lens larger than about 50 mm., and that is too short for most close-up work. But, equally, do not be a slave to this rule. In many linking sequences, especially of human activities in close-up, steadiness can be sacrificed for mobility and only by snatching brief opportunities with a hand-held camera will you be able to achieve the glimpses of natural behaviour that will tell your story convincingly.

Balance

As you move the camera you must ensure smoothness and this requires not only an effective tripod head but also that the camera and lens are balanced. Ideally they should not tilt at all when the tripod head is unlocked, even when unheld. The larger the lenses you are using, the more important, and difficult, this is.

Lighting—natural and artificial

The clever use of natural lighting can enhance a film enormously. Most modern film stocks have enough latitude to allow a good deal of contrast in the subject. So it should now be possible to include very dark and very light areas in a shot at the same time without the distracting 'soot and whitewash' effect produced by excessive contrast. It is no longer necessary to shoot with the sun always over your shoulder. Try to vary the angle of the light as much as possible. Even shoot straight into the sun if you want, but remember to shield your front lens surface from direct sun-rays or your film may suffer from orange flare marks which can be unpleasant.

Dull days can give beautiful soft pastel colours. Sunlit scenes against heavy storm clouds can have great drama. It is wise to use the best variety of different lighting situations you can find. They will help to give the film variety and interest.

One of the secrets of the constantly accurate exposure you find in films in the cinema is the way the filming crews use batteries of

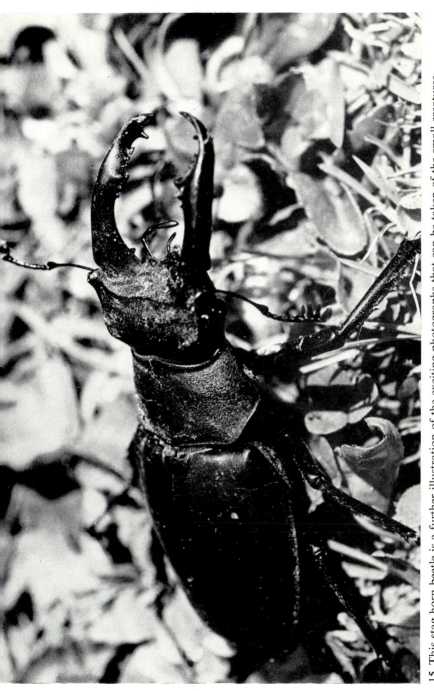

15 This stag horn beetle is a further illustration of the exciting photographs that can be taken of the small creatures. (See page 18)

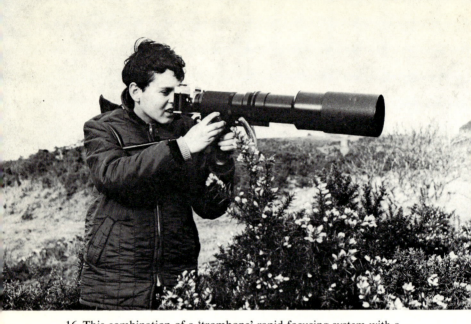

16 This combination of a 'trombone' rapid focusing system with a shoulder brace and a thumb stick for additional support is excellent for free-range photography. (See page 49)

17 These grouse were photographed at 1/1000 second. Even at this very fast shutter speed the wings have not been 'frozen'. (See page 60)

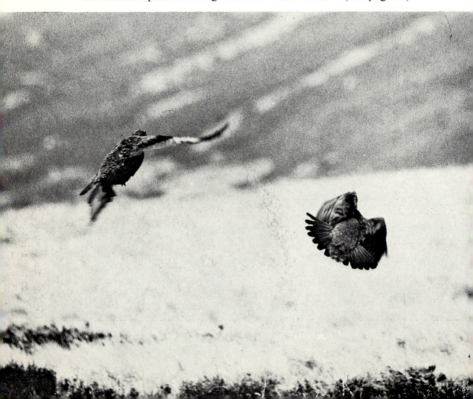

lights sometimes even on the sunniest of days. John Marchington makes this point well in Chapter 8 and all he says applies just as much to the cine man as for the still photographer. But natural lighting is all that is usually available for the wildlife photographer. Flash is obviously useless for filming except possibly in the most elaborate and expensive productions where synchronized repeating flash has been used. So we have to use continuously burning lights. These are power consuming, expensive and disturb the wildlife. So it is not surprising that they are used as little as possible, and only from fixed filming positions. It is essential to acclimatize your subject to lights as soon and as completely as you can. This is usually done by starting with a very low light-level and gradually building up the intensity until the subject will accept a high enough level for filming. It is not a technique for people with little time to spare and I would not recommend it for most amateurs. There are specialized fields, for instance insect macro-cinephotography, when lights become an essential item of equipment but require so much detailed and specialist knowledge that they are outside the scope of this book.

15

Sound

The technique of wildlife sound recording is, of course, a subject which requires a book of its own and I would remind you of the specialist books on the subject I recommended in Chapter 13.

There are, however, several basic points which give the bare bones of the subject and should set you well on the way to a really enjoyable hobby which can add tremendous effect to your films.

If you can possibly afford it buy a parabolic reflector. Grampion Reproducers Ltd., Hanworth Trading Estate, Feltham, Middlesex, sell a range of parabolic reflectors and microphones. You can make one yourself, its size and construction varies according to your needs. You will find very full instructions in the *Encyclopedia of Tape Recording No. 1* mentioned earlier.

Without a parabolic reflector you will find it difficult to add more than a background of natural sounds for wild animal noises in close-up can only rarely be recorded from a distance.

Remember that for real quality in sound you need a fast and steady tape-running speed (not less than 96 mm. [3¾ in.] per second).

It is best to buy a recorder and microphone that is at least in the medium-price domestic class. Modern cassette recorders can give surprisingly good quality but the very cheapest makes will not be capable of reproducing most wildlife sounds adequately.

Never record on a windy day unless you can keep the microphone really well-sheltered from the wind.

Always get your microphone as close to the subject as possible rather than turn up the record level. It can be very useful to attract birds close to the microphone (or indeed the camera) by playing back their own song or calls to them.

Apart from wildlife sound you can also record any other sound effects you may need such as water splashes, footsteps and so on.

Keep your microphone as close as possible to the sound you are recording. In this way you will be surprised how easy it is to cut out surrounding noises.

Unwanted noises are a real menace. If you stop and listen as you read this you will be surprised at the din that is going on around you. As I write I can hear just as background (and it is a quiet evening) a clock ticking, a refrigerator, a distant aircraft and distant traffic noises. Occasional louder sounds are surprisingly frequent.

An amateur sound-recordist friend of mine with twenty years' experience tells me that except for the Highlands and islands of Scotland (and they have their own special wind problems) there is really nowhere left to record wildlife sounds in Britain except at night. He now does much of his best work in Lapland.

There is much to be said for recording at night. Birds, especially, for example waders on an estuary, are often just as active at night as by day. Also many mammals are nocturnal.

If you have neither the time nor the opportunity to make your own recordings you can now buy excellent sound effects, which are published by B.B.C. Sound Archives (you will find them listed in your local record shop). These discs have a wide range of recordings of natural sounds such as sea, wind, and noises of the countryside in general. There are also many more rather interesting effects such as explosions, engine room telegraphs, babies crying and a host of others. These B.B.C. discs are 'copyright clear' and may be used on film without any rights payment even for public performance. Beware on this point. It is illegal in public (and that usually means outside your own home) to reproduce effects or music from most commercial discs without copyright clearance. Copyright clearance can be expensive. If you are in doubt write to the Mechanical-Copyright Protection Society Ltd., Elgar House, 380 Streatham High Road, London, SW16 6HR.

Sound is a marvellous thing on film, it adds more than a mere third dimension, it adds extra realism. But if you are going to use it do use it properly; poor quality sound is worse than none at all. I am sure you will best achieve these good results by concentrating on sound and sound alone while you are recording and not by trying to film at the same time.

Filming for editing

The Editor's Job

It has often been said that the greatest single stride forward in the cinema was made when someone first applied a pair of scissors to a piece of film. The person who wields the scissors is called the editor and he can make or break any film. It is he who controls the final pace of the film, he who must decide on the ultimate length of every single shot. He does not merely collect the shots and stick them together, he has a vital creative task to perform. In wildlife films, where precise scripting is generally impossible, he has an especially important job, for with ingenuity and perseverance he can often create a whole new sequence out of a series of apparently unconnected shots. But he can only do this if the shots have been taken with his primary needs in mind. It has been said that a good editor is like a good con man. This is obviously an exaggeration and unfair to a responsible task. But it is true that by mixing known truth with unknown lies he creates a feeling of confidence in the film which guides the audience through the unavoidable mixture of times and places that make up the sequences. However realistic a film may seem it can never be a strictly truthful record of events. It can never be better than a two-dimensional reconstruction of events in a time scale far shorter than they took to happen. By skilful editing, though, the many different shots can be combined to give a flow to the film which prevents the audience from noticing the necessary condensation of time and distortion of the precise order of events. If a shot were to be taken, for instance, which included the whole process of a bird hatching from its egg it would probably run for at least half an hour. It is the editor's job, aided and abetted by the cameraman, to reduce this time in a sensible and intelligible way.

The 'Jump Cut'

It would be simple just to cut out the least interesting parts of the shots and join together the bits that were left. But this would produce a distracting series of jumps or 'jump cuts' as, in a fraction of a second, the scene changed from one stage to the next.

The Mix

This problem is sometimes overcome by mixing, or lap dissolving, the beginning and end of each shot. This gives the effect of a visual 'and later' to the change of scene.

On cameras with a built-in fade device this can be done while filming. The camera is faded out at the end of a take, re-wound for some distance and faded in again at the start of the next take. Professionally this is not usually done in the camera but by the film laboratories when they are making the copies later.

The Cut-Away

Alternatively the problem of jump cuts can be overcome by using a 'cut-away'. This is a much more usual method for amateurs and consists of a selection of different but relevant shots which are placed where the jump cuts would otherwise occur. For example, a series of shots of an observer watching the scene from a distance might be used.

Changing the Angle and Size of View

There is a far more satisfactory way to avoid jump cuts and yet keep the film moving along; every sequence should be filmed with a variety of different shots. Wide-angle views, or long shots, should be well-interspersed with close-ups and the angle from which the camera is aimed at the subject should be changed as many times as you can manage. This will allow the editor to control the pace of the film in the cutting without being governed by having to use mixes or cut-aways to avoid jump cuts.

Letting the Subject out of Frame

When following a moving animal in close-up remember to let it move out of shot before stopping the camera. Provided the same direction of movement is maintained your next shot of the animal will cut comfortably with the first without any jump cuts.

An Example

Let us run through an example of how to 'film for the editor'. The sequence is of the annual 'mad' boxing display of a group of four hares in a field in March. Contrary to popular belief their display is not male versus male but usually male versus female. It is a pairing activity. The sequence should inform the audience of this, clearly and enthusiastically.

Let us suppose two minutes of film are required which show the place where the scene occurs and the action itself in detail. A small story should be made of the sequence. In reality the action takes place all morning in short bursts of activity, lasting on average 15 seconds and each interspersed by longer periods of inactivity lasting about 30 seconds each. But such precise timing is rather irrelevant because the activity and the pauses happen entirely at random and with very little warning.

The sequence is to be filmed from a car on a road which runs parallel to the field. You have available a zoom lens, and a 200 mm. telephoto lens. The zoom lens will give you a good wide-angle view showing the field and some distant scenery but at such a wide angle you can hardly see the hares on the screen. When zoomed in you have a shot in which an individual hare takes up to about one-eighth of the picture area, so a group of four hares, with the spaces between, take up about one-third of the picture area. This might be described as a medium long shot.

Using the telephoto lens if the hares are in the centre of the field, one animal will just fill the screen—a comfortable close-up.

Unless you have already studied the procedure on a previous occasion it may be sensible to spend time watching it before starting to film. But for most people the urge to get something 'in the can' in case the action stops will be too great. In any case there are sometimes strong arguments for starting to film at once. The weather

may be clouding over or you may know that the hares are likely to be disturbed soon.

My advice is not to fly straight to the telephoto lens. Work with the zoom lens first. Shoot one good long take of one session of activity with the lens zoomed in as far as it will go. Try to shoot the complete action in this one take, from the hare's inactivity stage through the boxing and running till they subside again. Once you have achieved this you have the core of the sequence. If the hares should suddenly run off you will have to cut your losses, take an establishing scenic or two and finish. At least you will have a sequence. If you had gone immediately to close-up and achieved nothing more the audience would get only a portrait of an individual hare and no idea of the action that was going on. A close-up generally seems to have little relevance to a wide-angle scenic if that is all that precedes it. So aim first to get the whole action of film in mid-shot. Then, if you can, change or adapt your lens and work for close-ups. They can be quite short takes.

The hares will be moving about so there is no real need to change the camera angle by moving the car, which anyway might well cause disturbance. Try to follow the direction of the action of that first long mid-shot so your close-ups can be cut in where you want them.

When you have achieved that, try to establish the scene in long shot. You may have to move the car to find a good composition, perhaps framing the field and the hares by a bush in the hedge or the rails of a fence. I have a personal dislike of the 'zoom in' which is so often used to establish this sort of sequence. It is surprisingly difficult to perform a really smooth zoom by hand and if you do it too often you will leave the audience with their eyeballs going in and out like organ stops.

There are other ways of establishing the hares. Perhaps you could take a scene of the road and its fence or hedgerow, compose on an attractive shot of say a tuft of wool on a fence or on a twig and pull focus into the hares in the fields beyond. Sometimes you can lessen the organ-stop effect by gently panning or tilting on to the subject as you zoom.

Once you have filmed the action in mid-shot and in close-up and have established the scene you can settle down to the really satisfying business of extracting the very best out of the events that are taking place in front of you.

117

Try to create a story out of the sequence. Build it up bit by bit if you can. For example you might show only one of the hares at first. Then another approaches. The first looks up. The other advances a bit. The chase starts, the first (the female) turns and boxes, then runs. The mad chase follows. Then follow this order with the second pair. The first pair carry on into the distance. The second pair's activity slows down and finally stops. The sequence ends.

You can build much of this, by careful editing, out of sensible filming in close-up provided you occasionally change to mid-shot and provided you let the animals move out of frame frequently.

Keep a story in mind as you film, ready to adapt your coverage as your theme develops. If, for instance, a cow appears in the field and the hares run, seize the opportunity. Film the hares going away then come back to the cow looking up and away at them. If you can, set up in a different position and try to entice the cow towards you again.

To summarize, do not be satisfied with individual shots as a sequence. Think of editing and what you will need to have in order to be able to tell the story. Aim for plenty of cut-aways and as few jump cuts as possible.

17

Creative filming

I hope that these previous chapters will have helped you to find out how to acquire some of the necessary practical skills to make wild-life films. This chapter is concerned with the creative aspect which is just as important.

Above the desk of one producer in the B.B.C.'s Natural History Unit are the words '*Entertain and Inform*'. These words and the order in which they are written are vitally important. Unless the people in the audience are entertained they will very soon become bored and once they are bored they are not likely to be receptive to information. So entertainment is a prerequisite.

Humour

Although there is certainly a place for thoroughly amusing films, which do little more than make the audience laugh, there are rather few wildlife subjects suitable for this treatment. It is for you to decide whether you feel that natural history films *should* give more than lightweight amusement.

Spoken humour is difficult to achieve and most of the laughs will come from the wildlife itself, spontaneously and without prompting by a commentator. It is generally a thoroughly anthropomorphic form of humour. The audience sees a reflection of absurd human behaviour in the antics of the wildlife. Consider why penguins, owls, pandas or monkeys can be so amusing—it is usually because they look human. Snakes, so very inhuman, rarely, if ever, make people laugh. To the animal itself, of course, a situation is not laughable in the same way as it may be to a human. A penguin waddling and sliding to the sea is not performing to an amused gathering of other penguins, it is simply carrying out an essential act which it must do in

119

order to survive. It is generally best to let these animals provide the humour without assistance from you.

Entertainment

What I really mean by 'entertainment' in this context is the amount of enjoyment that the audience derives from watching the film, not how many laughs it gets. The simple beauty of wildlife itself gives enjoyment to most people and in some films that is enough. In others though, where perhaps the wildlife is not intrinsically so attractive, it is necessary to entertain the audience by other means. Perhaps by interesting them in new information about the subject. This often requires real inventiveness.

The question of how much the audience should be informed by the film is quite tricky. Obviously a strictly educational film must inform as much as it can. On the other hand, many people do not like to feel that they are being taught by films; they prefer to have their interest aroused rather than their minds educated. But in many cases it is the new things they learn about wildlife that will fascinate them most.

'Art Form'

There used to be an argument which said that cinema was not as pure an 'art form' as, for instance, theatre. This argument is rarely heard now. I suppose it derived from relatively poor technical quality of picture and sound in many early films. The quality of materials now available means that, like the stage, the film screen can reflect good and bad art, but art it plainly remains. The more creative and the more skilful it is, the better it is and the more successful it will be. The truth lies in the dictionary definition of the word 'art' as 'creative skill'. If your films are creative and skilful you will have been an artist.

Descriptive versus Narrative Films

There are two basic types of approach to a film, the descriptive and the narrative. The first is a direct representation of the events that the camera filmed. The second creates a story which carries the film

120

forward. The first is a catalogue, the second is a story. To me the second is usually the most successful. This is not to say that descriptive, lyrical film-making cannot move the audience deeply, often by strong psychological tension. It is simply that the argument and reason behind story-telling is usually a stronger force. To be successful a great deal of planning and thought at all stages of the production is required. A great deal of this planning must be done before filming starts.

Stories

It has been said that every film should have a beginning, a middle and an end but not necessarily in that order. This is a film-maker's cliché now, but it is still true enough. There needs to be a unifying thread running through the film. So let us consider what story line we can choose.

The problem becomes immediately apparent; that the obvious story lines have all been used many times before and, whilst that may not necessarily rule them out altogether, it is bound to make originality difficult.

Probably the oldest approach of all is to follow the passage of the seasons. Even if this is not a main theme it is present in most natural history films. Unless the whole action takes place within one season it is almost essential to move forward with the year rather than back against it or dotting about within it. It is rarely sensible, for instance, to follow summer with spring or winter with autumn, for you will merely confuse the audience. But to use the passage of the seasons as a story line by itself does now seem rather weak.

Another popular formula is to follow the passage of one day from dawn to dusk.

This can be a very useful formula, especially if you have not much time to shoot the film. It's an ideal approach if you have just got a few days' holiday in one place.

Just a brief word about sunsets and why so many natural history films end with one. Sunsets nearly always give a story a sense of an ending and usually have to be followed by a pause. If this ending (accompanied by the usual fade-out) comes after the half-way mark in the film, the audience may get the impression that the film has finished. If the sunset is the most beautiful sequence in the film, and

121

that is very often the case, the effect may be a massive anti-climax when the film starts off again. So when you are shooting a sunset remember that it is likely to finish up as a grand finale and will need to be filmed as one.

A very useful, if also rather overworked, approach to the story line is to follow a river from its source to its mouth. This treatment will enable you to cover a great variety of different aspects of the countryside from high ground to the seashore. Again this is especially useful to the amateur film-maker on holiday who has probably only a fortnight or so in which to film.

A more ambitious approach but frequently a very successful one is to film through the eyes of another person, or even another animal. Perhaps the greatest advantage of this is that you can step away from the usual form of commentary with its direct style and allow your narrator to reflect and reminisce. It is a very useful method of linking random sequences as though they were the random thoughts of the narrator. Many of the best wildlife film sequences, like still photographs, are snatched without any time to film them around a precise script. This type of personalized film is often a very good vehicle for them.

Single species studies are always popular—as witness the success of the B.B.C.'s *Private Lives* series. The main snag with them is the vast amount of time needed to achieve a really full coverage of the life of the animal, particularly outside the breeding season. So this approach is more likely to be used by professionals than amateurs.

Films of expeditions are also very common. They give a good opportunity to include aspects of the countryside other than natural history and of course they are very useful for holiday film-making.

There is another form of treatment which is becoming very popular and which contributes to the problem of tying together apparently disconnected sequences. This is what is sometimes described as the 'lyrical' approach. Here the old prescribed forms of presentation are abandoned and the pieces of film are linked by other means. Perhaps a piece of music is used and the sequences are photographed in an interpretive way dictated more by the music than by a commentary or by a story. Natural sounds can be used for this effect. Or perhaps the lyricism of a piece of prose or poetry is used. One R.S.P.B. film took the concept of the spirit of wilderness that exists in an estuary as its theme. The words of the essayist and

novelist. J. A. Baker, were used for the commentary. His words were used sparingly and only where they amplified the picture (there were in fact only ten short sentences used). Every shot was designed to exemplify these words and the shape of the film became subservient to them. This approach requires of the film-maker a very intense knowledge of the idea behind it. It is difficult to achieve but it can be immensely successful.

These are the main methods of creating a story line that have been used for wildlife films in the past. Undoubtedly they will all be used again. But it is the new approaches that concern the creative film-maker. To help you think of other ways of scripting films is part of the purpose of this book so here is a list of some suggestions which may help:

The life of an individual bird or other animal from its birth to its death.

The story of how one human being acquired an interest in wildlife from vague disinterest to passionate concern.

The creation of a local gravel pit and its effect on wildlife.

The effects on wildlife of a new road, power line, airport, etc.

The remarkable differences between the various species of birds of your own garden, tits from starlings or starlings from sparrows.

The work of your local County Naturalists' Trust or other conservation organization seen through the eyes of an animal, or even a human being.

A montage of the attitude to wildlife of a cross-section of your friends.

A history of the changes in wildlife and scenery in your area over, say, the last fifty years.

A short examination in detail of a part of a local hedgerow or wood or even your own garden—the plants, insects, mammals, birds.

These few ideas may, I hope, give you a start. Remember that even if a new idea does not seem at first to be a worthy enough subject by itself, it might make a fascinating, although very short, film, if it is accompanied by another.

123

From filming to films

Now that we have discussed equipment, technique, the artistic and creative approach, and subjects to choose, we can discuss how to bring these together.

Making a Film as distinct from Filming

I have referred before to the importance of giving your films a beginning, a middle and an end. You will only achieve this if you have a clear idea of the shape of your film before filming any of it.

Professionally most films are very tightly scripted long before filming begins. Unfortunately wildlife films tend not to be given the benefit of this attention, mainly because it is usually impossible to guarantee that any one sequence will definitely be achieved. But for the benefit of sponsors as well as cameramen, an attempt is usually made to lay out the bare bones of the idea at least. This is frequently called the 'treatment'. I strongly recommend it to amateurs too. It is only too easy to film away without actually making a film.

The Treatment

How do you write a 'treatment'? Begin by stating the aim of the film. Is it to tell the audience something or is it mainly to entertain them? Is it to add to their appreciation of wildlife or merely to recall in them experiences which they have had but not remembered? Or is it simply to share with them your own enjoyment of wildlife?

Then fix firmly in your mind the type of audience the film is aimed at. Are they mostly quite knowledgeable about wildlife or are they, like most people, sympathetic but without much time to spare for it? Are they people who know you or casual acquaintances? Are they

country people or town dwellers? Or are they simply your own family who will probably have a great deal of initial knowledge of the facts behind the film? One of the secrets of a good film is that at all times the cameraman knows the type of audience the film is to be shown to.

Having decided, then, on the aim and the audience you should lay out in a paragraph or two the general approach to the subject. Here are just three examples.

A Film about Natural History and a Holiday on the Scilly Isles

AIM: To present an enjoyable 30-minute entertainment at the end of which a member of the audience will know what he or she can expect to see in the way of wildlife on a fortnight's holiday in the Scillies in June.

AUDIENCE: Family and friends. But also suitable, if all goes well and the film is successful, for small groups—for example a Women's Institute or Townswomen's Guild.

TREATMENT: The film approaches the subject as a report through the eyes of the cameraman. His arrival. His first impressions of the islands—attractive but with no apparent profusion of wildlife. The place where he is staying. The advertisements for local boat trips to other islands. Going aboard one of these and the views of the seabird colonies and seals intercut with a few close-ups (taken later). Landing on an island. The plant and insect life of that island. Returning from the island. The rain on another day (could probably be filmed on any suitable day—hopefully this is not every day!). The depression of the party. The feeling that they had already seen the best of the Scillies. The clear morning of the next day. The party realizing that the weather and the interest of the islands can suddenly change so quickly. The scenery of the islands on such a day. The shore and the rock pools. Rain again or a heavy mist (very likely in the Scillies). Again the disappointment of the party. But resolution—a determination to see as much as possible despite it. A visit to the bird observatory and lighthouse on St. Agnes. The past records of the observatory (which include some American rarities). The resident birds and flowers of the islands, not merely the seabirds which are summer visitors like most humans, i.e. the local starlings and sparrows and the local gulls

(which can be easily filmed by casting a few of your stale sandwiches to the winds) and, of course, the wild and cultivated flowers. A flash-back to the best shots of the visiting birds, especially the seabirds which make the main interest for the naturalist holiday maker. The journey home.

A Film about a City Sparrow

AIM: To present an entertaining examination of a common bird which everyone knows, the way it lives, why it is so successful and what are its problems.

AUDIENCE: Family and friends (though if the film is really good it could be shown to anyone).

TREATMENT: A backyard in London (or any other large city). The setting and its lack of wildlife. The pavements and a scavenging street cat. A barking dog. A wind-blown newspaper. One sparrow on a fence or wall. The reason why it is there—because there is food for it. The sources of its food. Dustbins, the local street-market, bird-table, the local park. How did it come to the city? It did not come. It was born there. The places it might have been born in (the eaves of a house, the privet hedge, the bush in the park, a nest-box). The way it was brought up by its parents. Its life as a young bird. Its chances of survival in its first winter. Its reliance on bird-tables during this time. Its desire to breed. Its aggressive instincts towards other sparrows. Its selection of a nest site. Its association with the film-maker's garden and with bird-lovers who feed it in its local park. A comparison of its life with that of a country sparrow. Its chances of survival in a competitive world—its special need for food in hard weather, its threats from cats (the urban predator). Its adaptability, its catholic tastes in food, its variety of nest site. In short the ubiquitous sparrow. We all know it. It is common and it is increasing. To some it is a pest, to others it is a small example of wildlife and vitality in an otherwise human-dominated environment.

A Film about Wild Flowers

AIM: To show that garden flowers are nothing more than wild flowers encouraged and organized by humans.

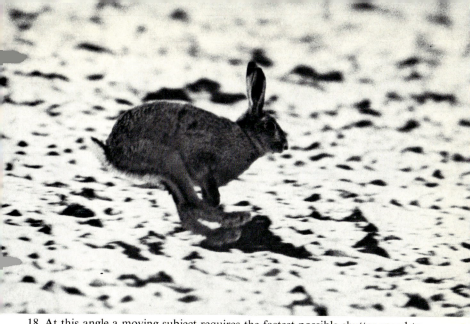

18 At this angle a moving subject requires the fastest possible shutter speed to freeze movement. Although taken at 1/1000 second this hare is not really sharp. (See page 61)

19 At close range, or when using telephoto lenses, the depth of focus is very limited. If you focus on the eye the remainder of the head will be as sharp as possible. An out of focus eye will be more noticeable than a blurred feather or beak. This photograph shows a hooded crow. (See page 63)

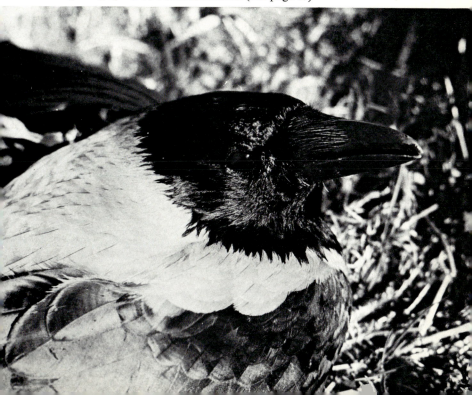

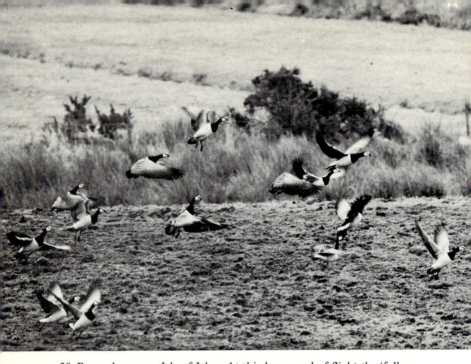

20 Barnacle geese—Isle of Islay. At this low speed of flight the 'follow and focus' technique was possible. (See page 65)

21 A cormorant swallowing a large eel—shots like this occur but rarely which is why the camera should be ready for instant use. (See page 75)

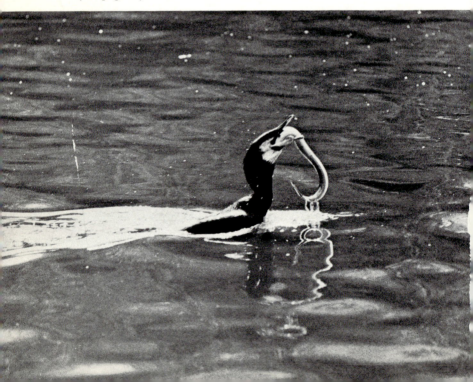

AUDIENCE: Family and friends and especially gardeners and local horticultural societies.

TREATMENT: The basics of a plant—how it lives, what it needs and how it reproduces. How any plant in the wild will do well only when the soil and the weather suit it. Why some wild flowers are large and some are small. Why some have flowers and some do not. Why some are heavily scented and some have no smell at all. Why some rely on self-pollination, some on cross-pollination, usually by insects and some use both. Why some are annuals and some perennials. Their attraction to humans. How some, like orchids, are loved. How some, like nettles, are loathed. The enjoyment that humans derive from them. How humans have changed them by selective breeding to bring out their 'most attractive characteristics'. How it is sometimes necessary for plant breeders to go back to the original wild plants to re-introduce 'desirable' features. The need, therefore, to retain a wild stock of plants each with its own habitat. The fact that a field of wild flowers can vie for aesthetic appreciation with any garden of cultivated species.

If you can collect together your thoughts and ideas in this way it will help you greatly to know what to film and what not to film during the relatively brief moments you have for photography. It will guide you too through the editing of the film and through its final production. For every minute spent in collecting your thoughts you will have saved hours in filming time and, what is probably more important, pounds in cost on irrelevant photography.

Research

Of course all this depends to a large degree on research. Many professional documentary films will have had more time spent on this than on any other part of the production and yet in very few amateur films is it even considered. This is a great pity because it is the one aspect of the production of a film which costs hardly any money. Perhaps the reason is that to most people 'research' sounds boring and since, by definition, amateurs make films for love of doing so rather than for money, they will always concentrate on the more interesting sides and especially on the photography itself.

Even so I do strongly recommend you to this research. You may

well find that not only does it make the filming far more satisfying and profitable but in itself it adds interest to your work and enjoyment by anticipation.

So how do you set about it? Try your local lending library. You will be astonished how many books there are on natural history subjects. For the examples I have given in this chapter for instance, a useful list of books would be:

Scilly Isles

The natural history of the Isles.
The local tourist guide and maps.
A history of the Scilly Isles.

The Sparrow

Birds of a city.
The Sparrow—a study of the species.
A study of the changing patterns of urban development.
'A Sparrow for Sixpence'—the story of a hand-reared house sparrow.

Wild Flowers

Any of the good wild flower identification books.
An atlas of the distribution of wild flowers in Britain.
A good simple guide to basic botany.
A simple guide to the common garden flowers grown in Britain.

At the same time don't be afraid to discuss your film project with anybody who is interested. I am sure it is a mistake to keep your ideas entirely to yourself. It is extraordinary how you will find that many people will have something they know that will help, be it a well-known place for seals on the Scillies, a sparrow nesting in an interesting place or simply a marvellous place to film wild primulas.

Your local camera or cine club may be able to help with equipment on an exchange basis. If you like to work in a team rather than on your own, they may well adopt, at your suggestion, a wildlife film to make.

Your County Naturalists' Trust may well be able to help with local matters or put you in touch with other Trusts who can help you with more distant enquiries.

Remember that you will usually need to get permission for access to film on most land that is not publicly owned. If you have to disturb any birds on Schedule A of the Protection of Birds Act (these are by and large the rarer British breeding birds but include for instance kingfisher and barn owl) at or near the nest, you must first obtain a licence from the Natural Environmental Research Council. (See Appendix.) All this should be worked out before you start to film.

Costing

If you are aiming at a modestly ambitious production it is as well to work out how much money you can afford to spend on each aspect of the production of the film, i.e. equipment costs and depreciation or hire charges, film stock, processing, printing (if you expect to have copies made), editing costs, reels and cans, etc., sound track costs, tapes, etc.

Given that you have already bought your equipment, the most expensive item by far will be film stock and processing. The processing costs are usually included in the price of film. Many professional film-makers do not expect to use more than 30 cm. of film for every 300 cm. they shoot. Many amateurs use virtually every frame they expose. I think it is reasonable to expect to film on a ratio of about 4 or 5 cm. to 1 cm. So if your film is to last for 15 minutes at sound speed, which is approximately 69 m. (225 ft.) of 8 mm. film, you will need to buy 274 m.–366 m. (900–1,200 ft.) of film (eighteen to twenty-five rolls). You should divide this up between the various sequences you will be tackling leaving a reel or two over for the unexpected.

If you are expecting to show the film many times it is advisable when it has been edited to have it copied. Although the quality of the print can never be as good as the original modern printing stocks can produce very satisfactory results, your master is saved from scratching and you have a splice-free copy to project. The cost of an 8 mm. print is not much more than the original cost of the same length of master with processing.

Once you have the equipment, editing will not cost you much,

just a bottle of film cement and under a metre of front and end leader and the reel and can. Sound, too, is surprisingly cheap because, of course, tape is not used up in the same way that film is—so wastage is minimal.

19

The shooting and the fun

Previous chapters have talked of the equipment, techniques and preparation. This chapter is about the shooting—to most of us much the best part of the hobby. Firstly, let us consider what it is that gives this pleasure.

I was started by an urge to show a doubting family something of what I had seen in the countryside around my parents' home in Surrey. If, I thought, I could attach a camera to the back of my binoculars and record what I was seeing I would be able to communicate my enthusiasm. I am sure it was partly a defence against criticism of the way I was wasting hours of time which could have been more profitably spent, from the family's point of view, in work or in one of the accepted sports.

Of course, at the age of eleven or so it was difficult to achieve much success at this especially with the hand-wound non-reflex, single lens Brownie box camera which I had hauled from under the dust in the attic. In fact, by projecting hours of shaky, black and white images of scarcely identifiable creatures, I must have done far more harm than good to my self-appointed cause of environmental education.

But by then the bug had bitten hard and once I had achieved one or two sharp close-ups of animals (and even a few grudging compliments from my sisters) I had realized that a large part of the pleasure comes mainly from the spirit of the hunt. In this respect I can see no great difference between still photography and film.

So, for myself the best of my fun comes in seeking out the difficult shot. The triumph comes in the knowledge of that shot 'in the can'. I enjoy the rest of the film-making but nothing compares to these infrequent moments of success.

It is well worth while identifying what *you* find most exhilarating.

Perhaps it is the outdoor life, being close to wild animals, achieving a shot that you know no one has even taken before, or very probably, simply the pleasure of having on record a part of an enjoyable experience with wildlife.

The answer to this inquiry should dictate your approach to the filming itself. If you like working in wild country tackle a subject like birds of the sea-cliffs, the natural history of the blue hare or the ptarmigan. If you prefer to film unique sequences on everyday species try working for a shot of a thrush bashing a snail on an anvil or a hedgehog 'self-annointing' with saliva (a common occurrence in summer). If you cannot easily get into the countryside and you enjoy overcoming the practical problems of filming small animals in captivity try a subject like the private lives of ants in an ants' nest —something you can film under controlled conditions in your own garden.

Whatever subject you choose and however you set about it sooner or later you will almost certainly experience the great by-product of the hobby, the unexpected piece of good luck. This comes in many different forms. It might be that a kestrel comes and hovers right in front of your camera when you are attempting to film something quite different. Or when you are filming a group of rabbits eating their way through some unfortunate farmer's spring wheat crop, a weasel comes hunting up the hedge line and you actually see and film the kill.

Perhaps you are filming butterflies on a buddleia bush in your garden and, just as you line up on a red admiral, a hover fly positions itself in flight right in your field of view.

The reason for these strokes of good luck is, of course, that by being in a good position to film wildlife you will be close to it and it will not know you are there. So you will be likely to come across much more than you would ever normally see.

I can well remember a five-hour wait for a chance visit of an osprey which was fishing in a pond in Surrey. When the bird finally showed up it turned out to be a juvenile. Nothing could have been better. Not only did it dive unsuccessfully for a fish half a dozen times but it ended up by catching two at once, one in each talon. It dropped the second back in the water as it flew off over the camera.

Methods of Approach

One of the real secrets of success is to be able to seize these opportunities as they arise. It is a good idea to establish yourself in your neighbourhood as a person who is always keen to know about anything that might be filmable. The best way of encouraging this is to follow up as many leads as you can manage. Show your films locally as much as possible. It is surprising how a small film show to a few people at a local hall can lead you to a comparatively tame local squirrel or a marvellous badger set that you had not heard of.

Some of the best opportunities can come from reared animals and birds that have been released to the wild but remain quite approachable.

Another line of approach is to take the subject on at its own game. Ron and Rose Eastman had a brilliant success with a pair of kingfishers nesting by a stream. They worked out what was the ideal type of bank to a home-hunting kingfisher and constructed a de luxe version complete with a built-in hide. This the kingfishers chose and produced not one but two successful broods.

As far as you can you must exploit anything that might attract your subject to you. This obviously means getting to know a good deal about it. How it behaves, what it eats, where it drinks, whether it will come to recordings of the calls of its own species, the time of day when it is most active and many other pieces of information.

Do not be afraid to ask questions. It is surprising what people will know. Only a few days ago I happened to ask some ten-year-old boys who were fishing for tadpoles whether they had seen any newts in that pond. Not only did they tell me all about the newts but also that this year they could only find toad tadpoles and no frogs. They were engaged in a local study of this with their school and had acquired not only an extremely workable knowledge about local amphibians but a good deal else besides. Often people do not seem to expect us to want to know about their experiences. The other day a friend said to me 'We had a cock greenfinch displaying just outside our kitchen window all last week. We thought of giving you a ring but guessed you wouldn't want to film such a common bird.' Nonsense, it is a subject I have been trying to film now for nigh on twelve years!

One of the most under-rated methods of approach is to use a car or van as a hide. Most animals and birds nowadays have plenty of

experience of motor vehicles and are not usually unduly frightened by them. I usually film in this way by removing one front seat of a van and filming through the passenger's side window. I hang a black cloth in the window through which the lens protrudes so that the animal cannot see movement inside. Jimmy Monro, a brilliant amateur wildlife film-maker working mostly in Yorkshire, has been achieving some superb results from this method. Wherever he drives he makes a mental note of the behaviour of birds and mammals which he sees near the road. When one of these observations becomes frequent he follows it up. In this way he has filmed some unique and fascinating sequences, for example his film of details in the family life of a group of snipe. These included intimate shots of a parent catching an earthworm and taking it to its young, something unknown about these birds, as far as I can find out.

Making Use of Weather Forecasts

Before setting out check the local weather forecast. I find that a telephone call to the nearest met. office for a regional forecast is usually well worth while. Nationwide forecasts cover too large an area to be very accurate for local conditions. You will find the telephone numbers of local forecasting stations under Telephone Information Services in any telephone directory. By checking in this way you should be able to plan your filming in any one day to fit the most likely chances of sun or whatever conditions you want. It will also forewarn you of exceptional weather conditions and this can be very important if you are filming in mountainous country or by the sea. I remember only too vividly 40 minutes with April cold water lapping at my waist in Morecambe Bay after my hide had been flooded out by a freak high tide whipped up by a wind that backed and strengthened in less than two hours.

So, with your techniques and equipment ready, your 'treatment' in hand, your research complete and with a clear idea of how much you are prepared to spend in time and money, you have shot your film. In the last two chapters we will think about how to complete the job.

20

After the shooting

Processing the Film

Each time a different batch of film is processed by the laboratories there is usually a slight change in the colour balance. Professionally this does not matter since the changes can be corrected quite easily when the film is copied. But if you are expecting to project your original, as are most amateurs, it is sensible if you can to send all the film you shoot for one production for processing at the same time. Then it will all be processed together and this colour balance problem will not arise.

Shot-Listing

When you project the film you will almost certainly feel a little disappointed. Even if all your focusing and exposures are perfect your memory will probably have enhanced what you filmed and the picture on your screen may well seem a poor presentation of what you saw when you were photographing it. But do not be put off, good editing can truly resuscitate an apparently boring and repetitive sequence. You must, however, tackle this editing in a logical way and the best method of approach is to make a clear and accurate list of what you have available. This is called a 'shot-list'. It may seem an unnecessary and tedious task but it will do more than save you time in the long run; it will allow you to view the shots and sequences from an overall position. It will also help you to locate shots far quicker than you could ever do by winding the film through a viewer.

Your shot-list can be a very simple affair. Since, as the editor, you will be the only person likely to use it, you can afford to abbreviate as you will. These columns are probably all you need:

1. The description of the shot or (if they are very similar) the groups of shots.
2. The direction of movement, e.g. 'Flying left to right'.
3. The size of the image of the subject on the screen, e.g. long-shot (L/S), mid-shot (M/S), close-up (C/U), big close-up (B/CU).
4. The length of the shot in metres or seconds.
5. The quality of the shot, e.g. over-exposed (O/E), under-exposed (U/E), out of focus (O/F or, more euphemistically, SOFT), contre-jour (C/J), shaky (Sh).

Editing Equipment and Techniques

To edit a film the equipment you will need is quite simple. An animated viewer, two rewind arms, a splicer, a rack for holding the shots and plenty of reels. It is helpful also to have a properly laid out bench and a reasonably dark room.

Unless you are fortunate enough to have a motorized editing machine you will have to acquire a certain basic skill in winding the film through the viewer at a speed that is reasonably near to the speed it was filmed at. It is only too easy to wind through too fast so that the shots seem shorter than they really are. One solution to this is to project the film very frequently at all stages of editing. This may seem tedious but unless you are very experienced it is almost essential.

Begin by studying the shot-list very closely and sorting the reels of film into the order that the sequences will follow. Then, taking the first sequence of the film, remove all the usable shots. It is advisable here to use a 'pin rack'. This is simply a board with a row of panel pins sticking out from it. The pieces of film hang vertically from this being attached by slipping a sprocket hole over one of the pins. The shots can easily be swapped around from pin to pin. Ideally you should have a brightly illuminated white wall behind it so that the shots can be readily identified.

If you have been able to film always with editing in mind you should have all the establishing and linking shots to hand. But many of the cut-aways you will eventually need will probably be hidden away in other sequences, so it is a good idea to mark the shot-list where they occur. This is probably more sensible than attempting

to remove all the cut-aways and then putting them together since there are likely to be a great many. Typical shots for this treatment would be mainly close-ups or mid-shots; for example people looking through binoculars, animals staring out of the screen as though watching the action, close-ups of eggs in a nest, the photographer in the hide or any close-up detail such as hands or eyes or feet.

As the editor it is up to you to ensure that film grammar is not broken unless intentionally. To refresh your memory (see Chapter 16) these grammatical howlers are likely to be either jump-cuts or uncomfortable changes of direction in the action of the subject.

A bird approaching its nest filmed with three jump-cuts can be overcome by intercutting the shot of the eggs in the nest. For instance, a hare running out of frame to the right should not re-appear in the next shot running in the other direction unless a cut-away has been inserted between the two shots.

You are likely to be surprised how simple it can be sometimes to create a little story out of a sequence using cut-aways and establishing shots by trial and error. Work your way through the film like this, taking up each sequence when the previous one has been assembled.

After grammar the next most important part of editing is pace. Here again trial and error will probably be the best method of approach. Cut the shots long at first and leave the final timing until you have passed the rough-cut stage which should be with the film at about twice its final running time. Try to distribute the faster cut sequences as evenly as possible between the slower ones. It is far easier to judge the rhythm and pace of the film when you can see it as a whole.

When the rough-cut is complete you can go through the film again shot-by-shot trimming and altering till it is down to the correct final length. Do not forget that it is far harder to replace part of a shot once you have cut it than to trim pieces off it.

Titles and Credits

These should be more than a mere credit to the cameraman and the other people who have worked on the film. The lettering, the position of the words on the screen and the positioning of the titles and credits within the film are all important.

There are three main ways to achieve this. You can set up the

words and film them to be separately inserted into the film. Perhaps you might even write the words on a suitable background, for example you might merely scratch them in a patch of sand. Or you can superimpose them by filming a suitable scene, rewinding the camera and, using the same piece of film, photograph the words white on a black background. Or you can film the words white on a black background and get a laboratory to superimpose them on to the film when copies are being made.

Choose lettering that fits the style of the film, ensure that the superimposed words do not conflict with a point of interest in the scene behind them. Hold the words on the screen for exactly the right length of time—usually about $1\frac{1}{2}$ times as long as it takes you to read them aloud slowly.

Editing Sound

Professionally this is a very elaborate business which may take as much as 30 per cent of the total production time. The sounds are generally transferred from 6 mm. tape or discs to 16 mm. or 35 mm. magnetic tape which has the same dimensions as the picture on the film concerned. This is then assembled to make up a number of different tracks or channels—perhaps one for the music, one for commentary, one for background sounds and one for specially synchronized effects. These channels are all mixed together in precise synchronization to achieve the final full sound track. It is usually a very expensive and elaborate performance which is most unlikely to appeal to amateurs.

But sound with your films should certainly not be altogether beyond your scope. It can be applied either on to the edge of the film as an optical sound track, read by the projector through a photoelectric cell, or as a magnetic track read by the projector through a magnetic playback head. Alternatively it can be played back on a cassette or standard tape recorder linked to the projector through a synchronizing device.

Whichever system you choose it is wise to take a leaf out of the professional's book and prepare more than one track to begin with and mix them together later.

There are many different ways of transferring the sound to achieve this and, together with tape-editing techniques, they must be beyond

the scope of this book. For further reading I recommend *The Technique of Documentary Film Production* by Hugh Baddeley, published by Focal Press. But a few words about the types of sound which are suitable to wildlife films may be helpful.

Do not, please, lard the background with insensitively used music. Beethoven's Ninth Symphony used as musical wallpaper on a film is not only a near-criminal treatment of great music, it will not help the film in the least. But an appropriate background of natural sounds interspersed with a few well-synchronized effects, e.g. plops, splashes, wing flaps, etc., will add a third dimension to your film. By all means add music in places if you want to but it must be relevant and it must add something either in an interpretive or atmospheric sense. Use silence sensibly; like music it can add more than itself by highlighting the change to natural effects or music when it finishes.

I repeat my suggestion that you should work with an amateur sound recordist on this if you can. Everyone has his own speciality and the visual side of film-making will probably keep you busy enough by itself.

Showing the film and outlets for it

So, the film is complete. What are you going to do with it? In its can it is useless, only when it is being projected is it achieving anything. So do not neglect this vital part of the subject. Bad projection is disastrous and can easily ruin the film altogether if, as you probably will be, you are projecting your one and only master.

The Screen

It is not advisable to project 8 mm. film on to a screen larger than 244 cm. (8 ft.) wide. 152 cm. (5 ft.) is probably the largest you will need if your audience is not more than fifty people or so. Use a good quality screen. Preferably one that can be washed down if it gets dirty or dusty. Position it high enough for all the audience to be able to see it well. People will very soon get used to having to look upwards to the screen—they will never get used to having someone's head in the way.

The Projector

Ideally the projector should not be in the same room as the audience, it should be in a sound-proof projection box with a double plate-glass window. But it is unlikely you will be able to arrange this and with the modern, much quieter projectors the problem of machine noise is not as great as it used to be. Ensure that the projector is set high enough so that the projected beam of light will comfortably clear the head of the tallest member of the audience.

The Speaker

If you are projecting the film with sound, position the speaker as near to the level of the ears of the audience as possible. You may have to alter its position after the audience has arrived because their presence will dramatically change the acoustic properties of the room. It is best to place the speaker immediately behind the screen provided this does not seriously muffle the sound—most cinemas have perforated screens which overcome this problem.

If you are giving a live commentary to the film stand in a position at the front of the room where you can see the screen out of the corner of your eye without turning away from the audience.

Lamp Strength

Make sure that you use a projection lamp that still gives a bright picture. Use old lamps for editing projection when a blow-out does not matter so much. Good black-out in the room will help picture brightness enormously. This can be difficult to achieve in summer so winter evenings are usually the best times for film shows.

Basic Precautions

Always keep a spare projection lamp handy together with a spare exciter lamp for the sound system if necessary, a roll of sellotape or a splicer for film breaks and an adequate supply of take-up reels of the correct size. Clean the projector and the lens before every show. Make sure the sound amplifier has warmed up before you start. If the projector is cold run it without film for about five minutes and always test-run the film before the audience arrives. Make sure you have someone ready to turn the room lights on and off.

General Remarks on Presentation

It is often a mistake to give a talk at a film show. A few words of introduction, especially if they help to make the film more applicable to the audience, can be helpful but a film show should be a film show and not a mere talk with a piece of film at the end of it.

Do not show too much film. The audience should leave the room thinking 'I could happily have seen a bit more of that.' A programme

141

of three or four short wildlife films is usually much more successful than a programme of one long one. In any event I think that 20 minutes is, on average, about the ideal length for an amateur wildlife film.

Choosing Your Audience

For 8 mm. presentation an audience of 100 people is really a maximum so, apart from your own family and friends, it will be local groups and clubs, etc., that are likely to form your public.

Women's Institutes and Townswomen's Guilds are very interested in natural history and will usually at least be able to pay your expenses. Even in country areas they can often muster audiences of more than thirty. Rotary clubs, photographic clubs, natural history societies could all obviously provide good and interested audiences. Or you may get more satisfaction from showing to your local old people's home or hospital.

A one-hour presentation will probably be about right, two hours is usually too long except to devoted wildlife enthusiasts who have been known to watch film for three hours *and* ask for more!

Though they frequently have a 'silver collection' as a general rule it will not be possible to charge for admission to these shows so you cannot expect much of a fee. If you want to make money, perhaps merely to pay for your film-stock costs, you must let the organization know about it from the start.

Professionalism

If you want to do more than recover some of your costs you are stepping out of the realms of amateurism and you will have to change over to professional equipment and, unfortunately, the professional financial problems that go with it. This means 16 mm. which is usually at least twice as expensive as 8 mm.

I cannot do more here than outline the possibilities for the professional wildlife cameraman. But you will find *The Technique of Wildlife Cinematography* by John Wareham published by the Focal Press and *An Introduction to Wildlife Film Making* by Christopher Parsons, published by David and Charles, both very helpful. For film-making techniques I can strongly recommend *The Technique of*

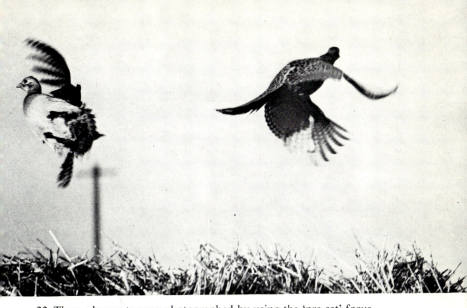

22 These pheasants were photographed by using the 'pre-set' focus
method after they had been spotted crouching behind a potato
clamp. (See page 67)

23 The strong light has brought life, contrast and texture to this
photograph of a hen pheasant, a normally drab bird. (See page 69)

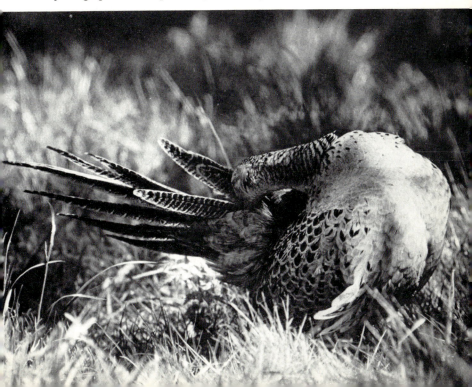

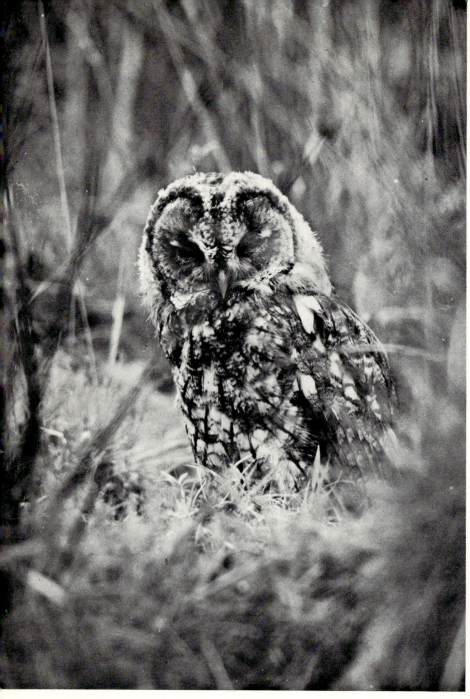

24 This photograph of a tawny owl is a good example of an 'opportunist' shot. (See page 75)

Documentary Film Making by Hugh Baddeley, also published by the Focal Press, which publishing house has a fine range of useful books on its lists.

Career Opportunities

Briefly, the possibilities are these: despite the current decline in the film industry there remains a shortage of talented wildlife director-cameramen. The qualities required are unfortunately far beyond a mere enthusiasm for the subject. A life-long interest is important. So also is a full grounding in all aspects of documentary film-making. A strong, practical streak, drive and application are essential because of the inevitable problems of wind, weather, inaccessibility and the intractable nature of the subject. But above all is the question of *talent*. This talent requires a latent ability to compose the picture not slavishly 'with the sun over your left shoulder' but in all conditions to present the subject on the screen in its most real and attractive way, using natural lighting to the fullest effect. It requires a driving enthusiasm for new approaches to the subject. Perhaps it is best defined as 'a real personal empathy for wildlife which is translated by technical ability, hard work and perseverance and thus made infective to the audience'.

With this talent you can approach the people who are likely to be looking for wildlife film-makers. The B.B.C. Natural History Unit in Bristol have made many very fine natural history films for television. Many well-known naturalist film-makers have come to prominence through the Unit—Jeffery Boswall, Christopher Parsons, Tony Soper, Ron and Rose Eastman to name a few. The B.B.C. also commissions films from freelance film-makers and for many years the Corporation championed the work of amateur wildlife cameramen. But times have changed and a proven film-making ability either from the film-maker's own production or by training with the Corporation (frequently starting in a lowly position) are now essential.

A similar situation exists with Anglia Television whose wildlife series *Survival* has been so very popular.

The Royal Society for the Protection of Birds has given opportunities to several young film-makers in its Film Unit but, again, the Society now requires some proven ability before it will employ new cameramen.

The County Naturalists' Trust movement have made use of amateur as well as professional film-makers and, as does the R.S.P.B., it uses film as an important part of its publicity, educational and membership recruitment activities.

My advice is first to learn the basic techniques by practical experience. Then, when you have a film or two to show, take your work along to one or more of these organizations. You will be very unlucky not to receive at least a sympathetic response and, even if you are unsuccessful, you are likely to learn a great deal by the experience.

If you cannot afford to start in 16 mm. use 8 mm. The principles are the same and if you have the talent required to become a professional it will show through.

Whatever your approach, amateur or professional, you will be engaged in one of the most satisfying and creative tasks there can be. At times it will be intensely frustrating, at others it will be intensely exhilarating. As your experience, equipment and materials improve, your opportunities will increase. One thing is sure, the subjects ahead of you will be enough to keep you busy for far more than a lifetime.

Appendix

The Protection of Birds Act 1954 laid down very comprehensive legislation for the protection of wild birds, and this was extended by the Protection of Birds Act 1967 (referred to as the Amending Act).

Section Four of the Amending Act is very important to the wildlife photographer for it contains special penalties for any person who wilfully disturbs any wild bird in the Schedule One list whilst it is on or near a nest containing eggs or unflown young. A person shall not be guilty of an offence by reason of anything done by him if he has been granted a licence for photography by the Natural Environment Research Council, but obviously these licences are not easily obtained. The Schedule One list is printed below.

There are many birds which can be photographed at all times without fear of committing an offence, and the Royal Society for the Protection of Birds publishes an excellent little booklet called *Wild Birds and the Law*, which lists the various Schedules, and sets out the law in simple terms. The address of the Society is The Lodge, Sandy, Bedfordshire.

Protection of Birds Act 1954 to 1967
(Schedules as at 1 May 1971.)

Avocet	Chough
Bee-eater (all species)	Corncrake
Bittern (all species)	Crake (spotted)
Bluethroat	Crossbill
Brambling	Diver (all species)
Bunting (snow)	Dotterel
Buzzard (honey)	Eagle (all species)

Fieldfare
Firecrest
Godwit (black-tailed)
Goshawk
Grebe (black-necked)
Grebe (Slavonian)
Greenshank
Harrier (all species)
Hobby
Hoopoe
Kingfisher
Kite
Merlin
Oriole (golden)
Osprey
Owl (Barn)
Owl (Snowy)
Peregrine
Phalarope (red-necked)
Plover (Kentish)
Plover (Little ringed)
Quail (European)

Redstart (black)
Redwing
Ruff and Reeve
Sandpiper (wood)
Serin
Shrike (red-backed)
Sparrowhawk
Spoonbill
Stilt (black-winged)
Stint (Temminck's)
Stone curlew
Swan (whooper)
Tern (black)
Tern (little)
Tern (roseate)
Tit (bearded)
Tit (crested)
Warbler (Dartford)
Warbler (marsh)
Warbler (Savi's)
Woodlark
Wryneck

Index

INDEX